KU-081-755

Vibrant
WATERCOLOURS

Hazel Lale

How to paint with drama and intensity

SEARCH PRESS

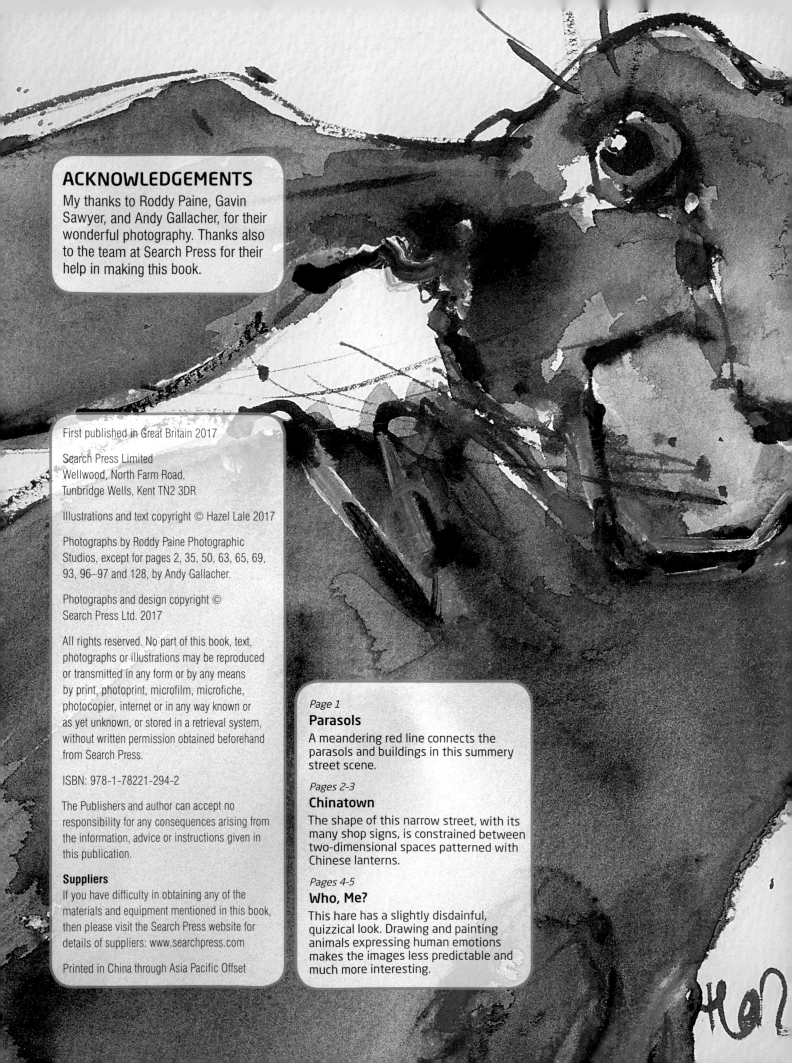

ACKNOWLEDGEMENTS

My thanks to Roddy Paine, Gavin Sawyer, and Andy Gallacher, for their wonderful photography. Thanks also to the team at Search Press for their help in making this book.

First published in Great Britain 2017

Search Press Limited
Wellwood, North Farm Road,
Tunbridge Wells, Kent TN2 3DR

Illustrations and text copyright © Hazel Lale 2017

Photographs by Roddy Paine Photographic Studios, except for pages 2, 35, 50, 63, 65, 69, 93, 96–97 and 128, by Andy Gallacher.

Photographs and design copyright © Search Press Ltd. 2017

All rights reserved. No part of this book, text, photographs or illustrations may be reproduced or transmitted in any form or by any means by print, photoprint, microfilm, microfiche, photocopier, internet or in any way known or as yet unknown, or stored in a retrieval system, without written permission obtained beforehand from Search Press.

ISBN: 978-1-78221-294-2

The Publishers and author can accept no responsibility for any consequences arising from the information, advice or instructions given in this publication.

Suppliers

If you have difficulty in obtaining any of the materials and equipment mentioned in this book, then please visit the Search Press website for details of suppliers: www.searchpress.com

Printed in China through Asia Pacific Offset

Page 1
Parasols

A meandering red line connects the parasols and buildings in this summery street scene.

Pages 2-3
Chinatown

The shape of this narrow street, with its many shop signs, is constrained between two-dimensional spaces patterned with Chinese lanterns.

Pages 4-5
Who, Me?

This hare has a slightly disdainful, quizzical look. Drawing and painting animals expressing human emotions makes the images less predictable and much more interesting.

Z987020

Libraries
lloedd

Vibrant
WATERCOLOURS

DEDICATION
To Thomas Lale,
Paul Boulding and
Andy Gallacher.

CONTENTS

INTRODUCTION

My earliest recollection of anything to do with paint and paper is from 'colouring in' at school – an activity which we all enjoyed. It started a fascination with colour for me. During a childhood trip to an art gallery, I remember asking why the artists painted portraits with unexpected colours: I didn't think that people's faces were white – or even green, as some of the works showed.

I grew to love drawing and painting, and started sticking an assortment of scribbled drawings, notes and memorabilia into various scrapbooks, which all eventually became crammed so full that they required elastic bands and string to keep them from falling apart. Eventually, my long-harboured ambition of becoming a full-time student of art came to reality. I gathered together a collection of drawings, scribbles and mix-and-match paintings (though I hesitate to give them such a grand title now) to present, and this collection saw me accepted into art college. It was an environment filled with the wonderful aroma of wet paint, where we were all encouraged to explore subjects, colours and materials without restraint. 'Find your own path' was the mantra.

As I explored, my art began to focus on large-scale work of muted tones, but over the years my pure childhood love of rich, vibrant colour re-emerged. Art is a journey. My collections of sketches and souvenirs are ongoing, and have helped me to form and develop my own painting style through challenging techniques and understanding how important colour was – and remains – to me.

This book will help guide you in producing your own vibrant watercolours and start you on the next chapter of your own journey. My hope is that the title will encourage you to look again at things around you – even seemingly everyday objects – and be fearless about how you can use colour to create excitement in your painting.

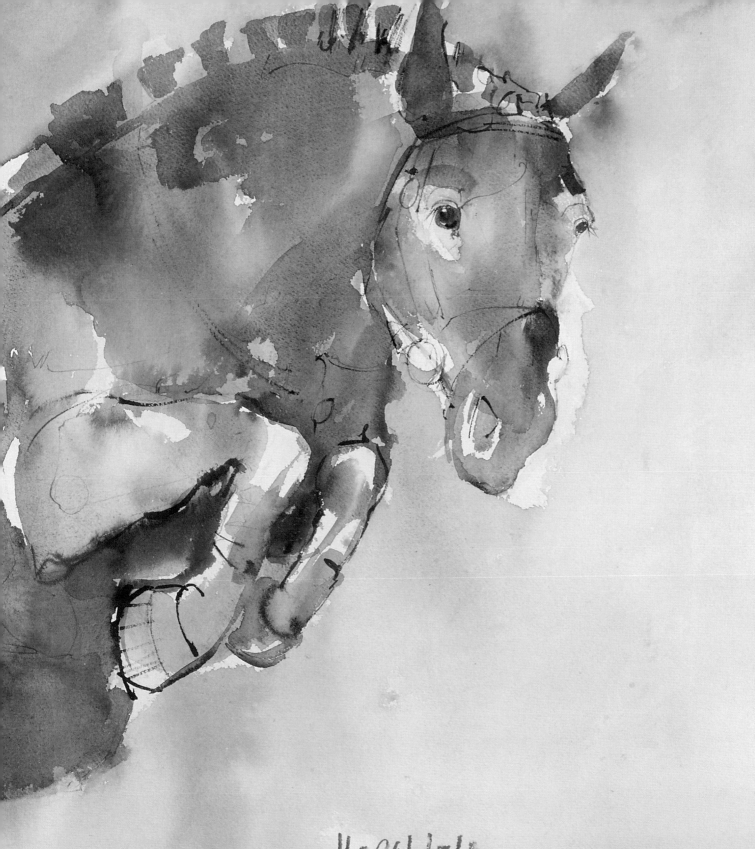

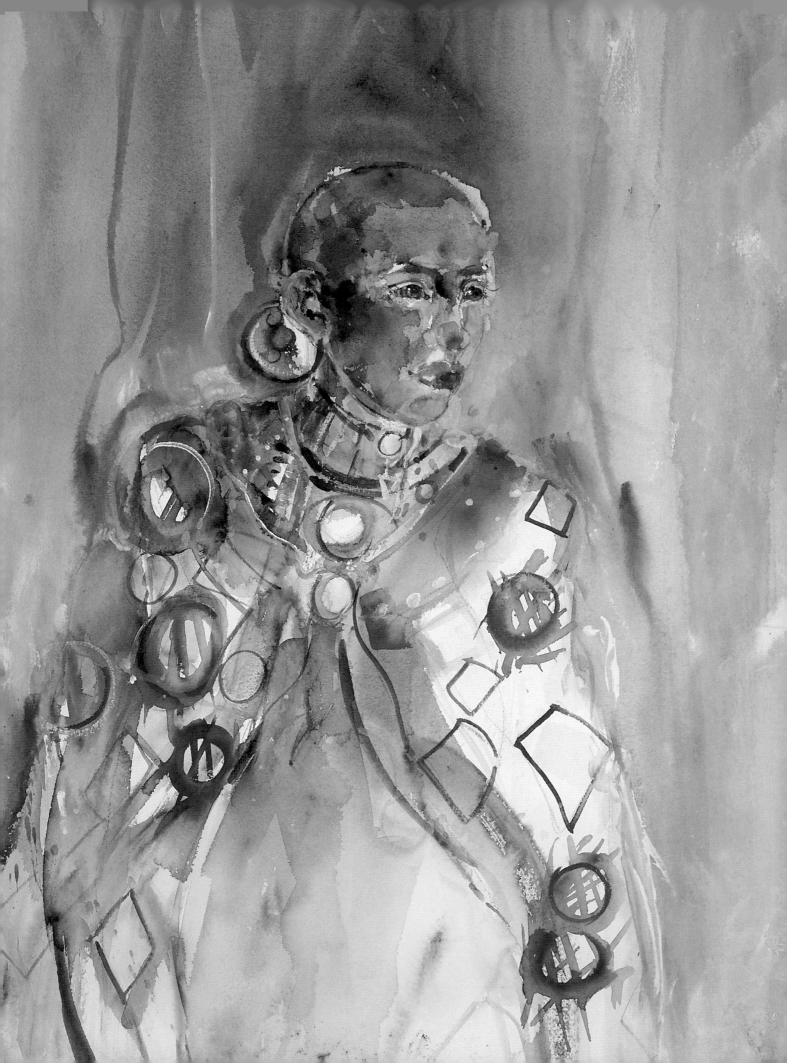

THE VISUAL LANGUAGE

Through the direction, size and arrangement of the marks made by the artist, every painting tells a story. Learning to read and paint this 'visual language' will enable you to work out how best to bring vibrancy to your artwork and how to build your artwork towards a certain goal.

The five important concepts below are the key components of the visual language. None of them are used in isolation – a stroke of the brush will necessarily impart both colour and shape, for example – but before we start looking at what to use and how to paint, it is important to understand that vibrancy is not achieved purely through the use of striking colours, nor how the paint is applied, but through the combination and interaction of the five factors described below.

COLOUR The colours you choose are important to how vibrant your painting will appear. Using complementary colours – such as the orange and blue shown here – next to one another will make both appear brighter and more eye-catching through visual contrast.

LINE We rarely think of line in isolation, but the first mark we make is usually a line of some form. Lines direct the eye and provide energy and movement to the painting as the viewer's eye follows them.

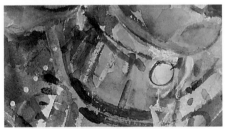

SHAPE Once we begin describing what is in front of us, we are making shapes. They are the building blocks of a composition. A completed drawn shape is referred to as a positive space, while the area surrounding it is referred to as a negative space.

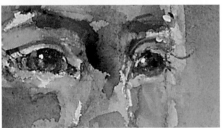

FORM The term used to describe three dimensions or implied deep space on a two-dimensional surface (i.e. the flat painting surface) is 'form'. Use of the other aspects of the visual language combine to create the illusion of form.

PATTERN A pattern is made up of repeated similar shapes. When you draw out a composition that defines your ideas, you are essentially pattern-making. Patterns can be used to create rhythm in your work – placing a pattern of similar-sized shapes in an area will suggest calmness, which can be contrasted with a pattern of differently sized shapes elsewhere.

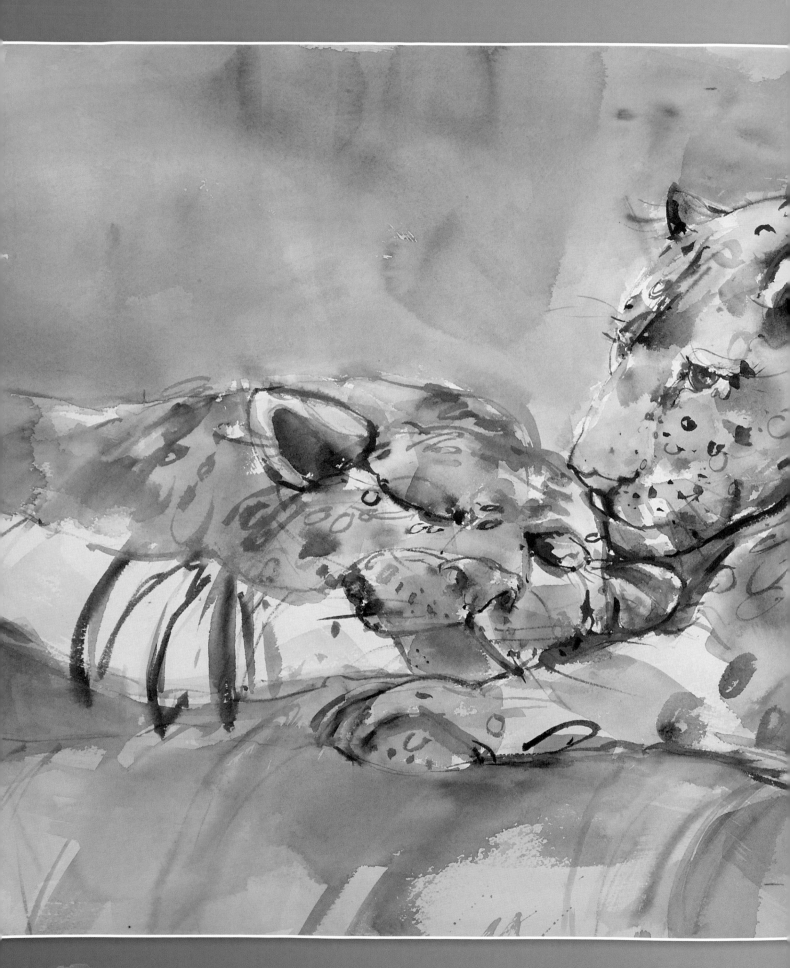

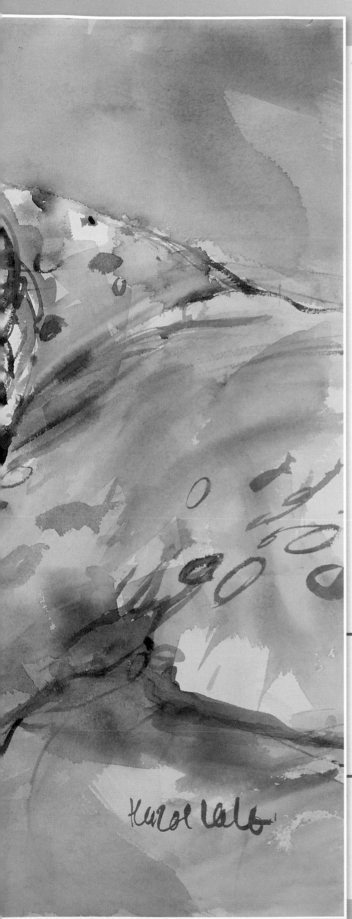

The visual language in action

The painting on these pages, of a pair of snow leopards, demonstrates how I have used the elements of visual language (see page 9) to produce a vibrant finished artwork.

Winsor lemon and rose madder were the main colours I used for this painting, applying them in loose washes. These complementary colours set each other off when placed near to each other. Once the initial washes were dry, I painted irregular curved lines onto the branch to suggest its form.

Note the use, in the centre of the painting, of dynamic diagonal lines which describe the nose of the right-hand leopard. The width of line used around the two leopards' muzzles varies, which helps to define and emphasise the form of the mouths and noses.

The raised head of the right-hand leopard gives height and movement to the overall composition, while the shape of the circles on the soft, patterned fur help to suggest the form of the animals' elongated bodies. Note how the width and shape of the circles within the patterns change as they curve round the right-hand leopard's legs and neck adding to the illusion of its three-dimensional form.

⫸ What do we mean by vibrancy?

Vibrancy in watercolour is best explained as those qualities of the artwork that catch the viewer's eye as the image bounces off the painted surface. Vibrancy is the sum of the elements of the painting that grab and keep your attention. Placement of colour in unexpected shapes and spaces is fundamental to giving your artwork an appeal that will keep the viewer looking. Care must be taken to avoid overdoing it – using too many eye-catching elements will result in a work that is over-busy and disjointed.

Snow Leopards

Sitting down in proximity to these snow leopards was overwhelming. I spent some time simply sitting and absorbing the spectacle before beginning to record in a sketchbook what was in front of me, using splashes of colour on top of quickly made pencil drawings. The images and notes I took have been the inspiration of many paintings, and will no doubt inspire more in future.

MATERIALS & EQUIPMENT

Using different materials to explore a subject is a fact-finding experience which allows you to sort out what is important. The following pages detail the materials I use for my artwork, so that you can join me on this expedition.

You have an idea, or have seen something that has inspired you to start exploring a particular subject. Where to start? The media I would suggest that you use initially are pens and pencils – those you likely already use for doodling and taking notes. With these simple materials you can produce everything from quickly drawn thumbnail sketches to larger drawings, which will help you with the process of looking, thinking and working through an idea before you begin to work with paint and brush.

Sketchbooks

Sketchbooks are invaluable for helping to develop your ideas. They are widely available in a variety of styles and formats, including different kinds of paper. If you choose a smooth paper it will take many different kinds of media.

Pick a sketchbook that suits you. The sketchbooks I prefer to use are square, a format that conveys a feeling of modernity and which encourages me to pick up the sketchbook and use it.

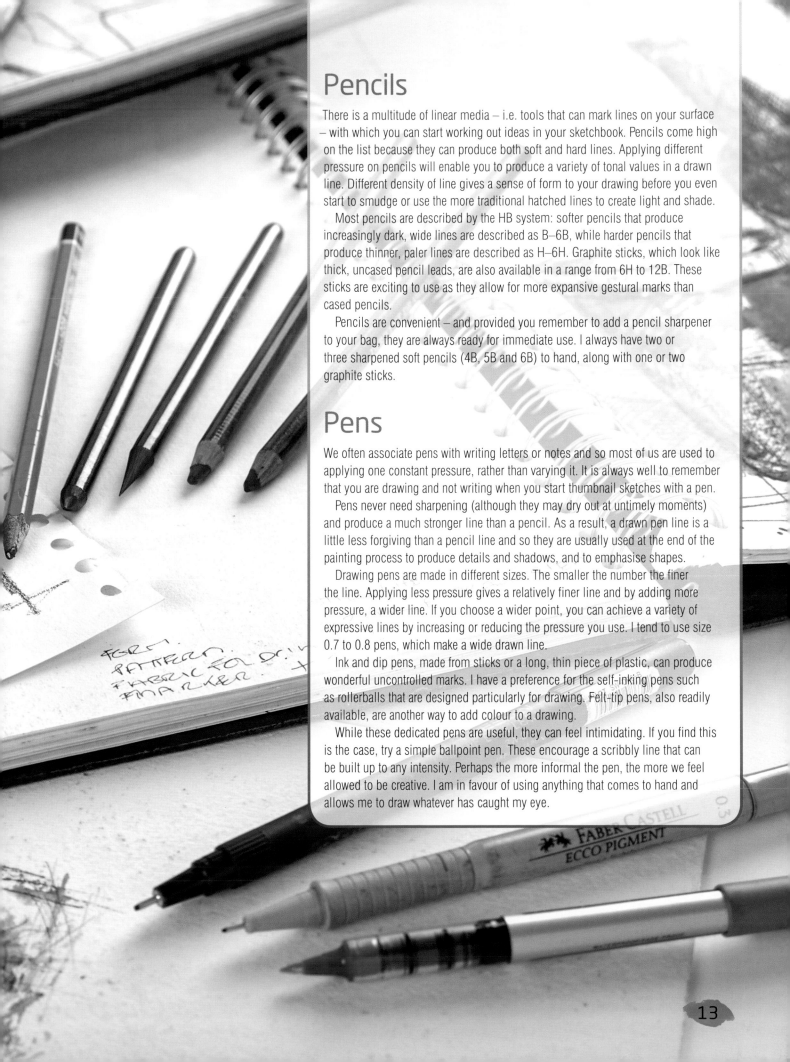

Pencils

There is a multitude of linear media – i.e. tools that can mark lines on your surface – with which you can start working out ideas in your sketchbook. Pencils come high on the list because they can produce both soft and hard lines. Applying different pressure on pencils will enable you to produce a variety of tonal values in a drawn line. Different density of line gives a sense of form to your drawing before you even start to smudge or use the more traditional hatched lines to create light and shade.

Most pencils are described by the HB system: softer pencils that produce increasingly dark, wide lines are described as B–6B, while harder pencils that produce thinner, paler lines are described as H–6H. Graphite sticks, which look like thick, uncased pencil leads, are also available in a range from 6H to 12B. These sticks are exciting to use as they allow for more expansive gestural marks than cased pencils.

Pencils are convenient – and provided you remember to add a pencil sharpener to your bag, they are always ready for immediate use. I always have two or three sharpened soft pencils (4B, 5B and 6B) to hand, along with one or two graphite sticks.

Pens

We often associate pens with writing letters or notes and so most of us are used to applying one constant pressure, rather than varying it. It is always well to remember that you are drawing and not writing when you start thumbnail sketches with a pen.

Pens never need sharpening (although they may dry out at untimely moments) and produce a much stronger line than a pencil. As a result, a drawn pen line is a little less forgiving than a pencil line and so they are usually used at the end of the painting process to produce details and shadows, and to emphasise shapes.

Drawing pens are made in different sizes. The smaller the number the finer the line. Applying less pressure gives a relatively finer line and by adding more pressure, a wider line. If you choose a wider point, you can achieve a variety of expressive lines by increasing or reducing the pressure you use. I tend to use size 0.7 to 0.8 pens, which make a wide drawn line.

Ink and dip pens, made from sticks or a long, thin piece of plastic, can produce wonderful uncontrolled marks. I have a preference for the self-inking pens such as rollerballs that are designed particularly for drawing. Felt-tip pens, also readily available, are another way to add colour to a drawing.

While these dedicated pens are useful, they can feel intimidating. If you find this is the case, try a simple ballpoint pen. These encourage a scribbly line that can be built up to any intensity. Perhaps the more informal the pen, the more we feel allowed to be creative. I am in favour of using anything that comes to hand and allows me to draw whatever has caught my eye.

Watercolour paints

Watercolour paint is available in tubes and pans. Pans are hard blocks of pigment that require wetting to use, while paint from tubes is already soft and easy to use. I prefer to use tube paint, and squeeze it out into the wells of my palettes. If the colours begin to dry in the palette wells, you can simply spray them lightly with water. This keeps the paint fluid and ensures you can pick up enough paint.

Squeeze out enough of each paint to completely fill each pan of your palette. This will allow you to pick up enough paint that you do not need to keep reloading your brush – a meagre amount of paint and colour mix can make for a half-hearted painting, as it is tempting to try to make it stretch to finish the area you are painting.

Paints are also available in different qualities. I invariably choose artists' quality paint over cheaper students' quality options. Artists' quality colours contain more pigment, are easier to use and produce better results. Some colours fade and others darken with time. The ASTM (American Standard Test Method) rates paint from 1 for excellent permanence, to V for poor. Some manufacturers have their own rating system. Whichever type you choose, look for permanent paints, which will be marked as such on the tube or packet.

Palette

Two large folding metal palettes with multiple wells are my choice for painting with watercolours. The palettes open up to provide flat spaces for mixing and at the sides are individual wells for holding the paint. A large flat brush is difficult to get into one small well and so I occasionally use two or three wells for just one favourite colour; as you can see with Winsor lemon in the picture on this page.

I use the wells on one palette to hold the darker shades of paint and the second palette for lighter colours. This helps to keep the light colours clean. Some pinks occasionally join the yellows and oranges (light colours) in the first palette when I have run out of space in my second palette. The pinks start again in the second palette, next to which are the light blues and turquoises.

At the end of a painting session I wipe clean the remains of the watercolour washes but leave the squeezed-out paint in the pans. This allows me to simply refresh the pans with water when I come to start the next painting, rather than squeezing out more paint.

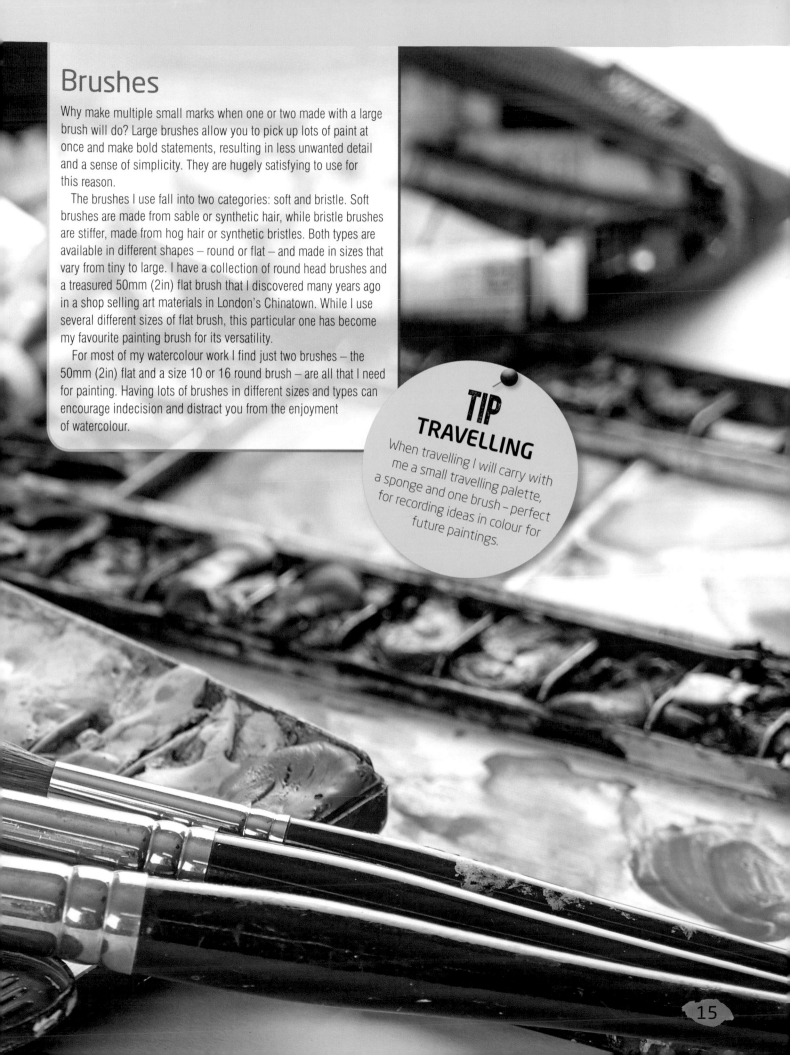

Brushes

Why make multiple small marks when one or two made with a large brush will do? Large brushes allow you to pick up lots of paint at once and make bold statements, resulting in less unwanted detail and a sense of simplicity. They are hugely satisfying to use for this reason.

The brushes I use fall into two categories: soft and bristle. Soft brushes are made from sable or synthetic hair, while bristle brushes are stiffer, made from hog hair or synthetic bristles. Both types are available in different shapes – round or flat – and made in sizes that vary from tiny to large. I have a collection of round head brushes and a treasured 50mm (2in) flat brush that I discovered many years ago in a shop selling art materials in London's Chinatown. While I use several different sizes of flat brush, this particular one has become my favourite painting brush for its versatility.

For most of my watercolour work I find just two brushes – the 50mm (2in) flat and a size 10 or 16 round brush – are all that I need for painting. Having lots of brushes in different sizes and types can encourage indecision and distract you from the enjoyment of watercolour.

TIP
TRAVELLING
When travelling I will carry with me a small travelling palette, a sponge and one brush – perfect for recording ideas in colour for future paintings.

Surfaces and supports

⫸ Paper

Paper is an integral part of painting, so take some time to work through the different options. When choosing a paper, you should think about its texture, absorbency and weight. Try out a few different types of paper to help find what might suit your way of working.

The majority of my work is painted on sheets of rough 640gsm (300lb) watercolour paper, generally at 760mm x 560mm (30 x 22in). I will sometimes divide this sheet of paper into two pieces but not usually anything smaller. Watercolour paper of this weight is amazingly resilient and reliable and will take most things you care to throw at it, including collage, inks and, of course, watercolour paint.

Handmade papers are a good alternative to manufactured rough surface paper. This is purely because the surface will have subtle differences in texture, which gives an element of surprise. Of course this could be either exciting or just too hard to handle!

⫸ Supports

I experienced a huge surge of anticipation and excitement the first time I was placed in front of an easel. This has never gone away. Nowadays I use an architect's drawing board which stands on legs. Its height is adjustable and I can pivot it to whatever angle suits me.

I usually start and finish a painting in my studio, and almost always stand to work. This is where floor easels come into their own. I can move back easily to get an overall view to evaluate my work and ask the question: is this painting working?

If I do sit down and work on a table, I use a wooden board large enough to accommodate the size of paper, which I tilt to an angle that enables me to see the whole painting surface.

OUTDOOR PAINTING

I very rarely paint with serious intent outdoors, as my process requires an amount of certainty about the surroundings. Even planning where I might easily set up my easel to work takes me a considerable length of time.

If I do make the decision to work out of my studio, I spend some time making a considered list of what I will need in order to draw or paint successfully. Even then, the thought of having to balance paper and a board on my knee makes working outside unattractive.

Other materials

Water pot and clean water Setting up your painting materials, brushes, paper and paint to start painting is all part of settling down to work. For me, having the right tools in the right place means I am halfway there. Clean water is part of that process, and essential for keeping your colours bright and pure.

Easel and clips If you choose to work outside, you could use a portable easel, but this needs to be lightweight and sturdy. Use clips to attach the paper to a drawing board and then sit for some time to ponder the vast choice in front of you before you begin.

Pencil sharpener and putty eraser These will keep your pencils ready to use, and allow you to make adjustments to your sketches and preparatory work.

Cloth rag or kitchen paper These are used to dry your brushes.

Camera A camera has become an integral part of my everyday life. I am never without my small compact camera, backed up by the camera on my phone. I get myself into all sorts of scrapes as the need strikes to take a photograph of a particular event, colour, graffiti and people. Today we all have cameras that do amazing things with colour and definition, and have the ability to alter tonal values. Cameras are amazing reference-gathering tools; but avoid copying the images they produce exactly – use them as just one of many ingredients that inform your paintings.

Inks Water-soluble coloured inks are one of my favourite media and I often use them alongside watercolour paints.

PVA glue After several watercolour washes have dried, PVA glue can be brushed on to protect the surface like a varnish. Once dry, you can then overwash the painting with watercolour or inks without the risk of disturbing the underlying washes.

Collage materials As long as it is relatively flat and able to be glued to the surface, almost anything can be used for collage. Such materials are commonly applied before painting, but you can also add them at any other time during the painting process. Newspaper print is one of my favourite materials to use in collage work.

Stencils Lettering is a favourite alternative ingredient in a painting and is easily applied with stencils. The strength of the letter shapes against the softness of watercolour paint is a great contrast. Stencils can also help when creating regular patterns, and can be made from found materials, such as packaging.

GATHERING IDEAS

Sketching

Everyone is a potential artist. Drawing in a notebook or sketchbook is a good place to begin thinking about the image you would like to paint. Make a habit of sketching the places you go and the people and objects you encounter. From these initial dashes of line and colour, large and small drawings will naturally start to emerge and your sketchbook will build into a visual diary. Events or problems you encounter can also be recorded – even the process of writing them down will go some way towards helping you to deal with them. Over time, the pages will start to fill with the beginnings of many potential ideas.

Take notes as they occur to you and mix the images and words together on the page. Gradually, a wonderful pattern, made of the places and events you encounter in your life, will begin to form on the blank pages. This exploratory drawing will quickly become second-nature and allow you to daydream while you do it, which will help you discover and explore the subject in front of you – even if some drawings are upside-down and end up wherever you happen to have opened the book!

Do not try too hard at this stage – and remember these sketches and written ideas need be seen only by yourself if you wish. Think of this stage as a fact-finding mission, where you simply record what is around you, and work out how to respond to it as you do so.

In addition to the drawings and notes, my sketchbooks all contain a treasure trove of interesting objects I have found on my travels and stuck onto the pages, from bus tickets to lettering on menus. Eventually my sketchbooks get so full that they are kept together only by an elastic band. These objects are a tactile reminder of a place or event, and they get my mind stirring as much as my notes or sketches.

There is always space in my bag for a sketchbook – the drawings may merely be a few lines and the notes brief, but they inform and inspire my picture making, as well as being a record of artistic progress over the years.

Observation

I enjoy the whole process of looking and drawing. Together with my written observations and thoughts, simple observation and careful examination forms the information-gathering part of my compositional process. While looking carefully, I usually spot a few additional details or interesting shapes in an area that I might otherwise have overlooked, and this helps the ideas for a painting to start coming together.

The initial idea or subject can become secondary to something you have seen in an unexpected place. For example, an exhibition of Native American fabrics and pottery gave me confirmation of a particular pattern that I have wanted to use for some time in a piece of work. I locked the idea away in a sketchbook until I could find the right way to use it.

The process will take some time, but there is no hurry. I always get the feeling that the next painting is always going to be better than the one I have just completed, so observation, time for thought and note-taking are just as important as the final painting for me.

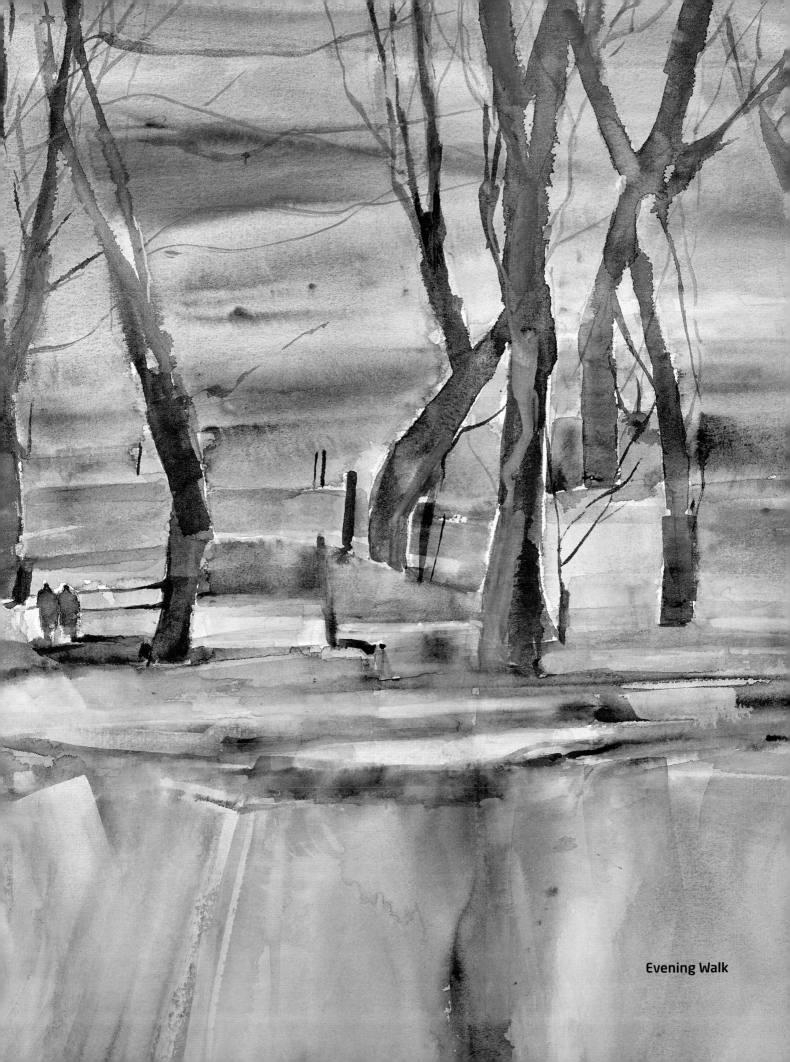

Evening Walk

EXPLORING THROUGH SKETCHING

Sketchbooks

Your sketchbook – which should be carried around with you at all times – is a journey that reflects your personal musings, an externalisation of thoughts and ideas drawn alongside your written notes. It can also be a refuge where you draw meditatively, with or without particular purpose. Alongside spontaneous quick doodles will sit thoughts and work that have taken some considerable time, such as studied drawings for projects. The sketchbook is a melting pot of different inspirations and influences, a place for trial and description of different media to use and try out. The range of possibilities is innumerable and the only limits are those that you give yourself.

The sketchbook represents the process of 'creativity' – capturing a thought or an image before it is lost. Using one helps develop a love of drawing and experimentation in your personal work. The treasure trove of details and insights that you record here may find their way into pieces of work, help you pick a starting point, help you make decisions – or they may simply offer you an insight into your artistic journey.

THE MASTERS
Many famous artists have used sketchbooks – Pablo Picasso, Leonardo da Vinci, Albrecht Dürer, Nigel Hall and many more. Indeed, Picasso said 'To draw, you must close your eyes and sing.'

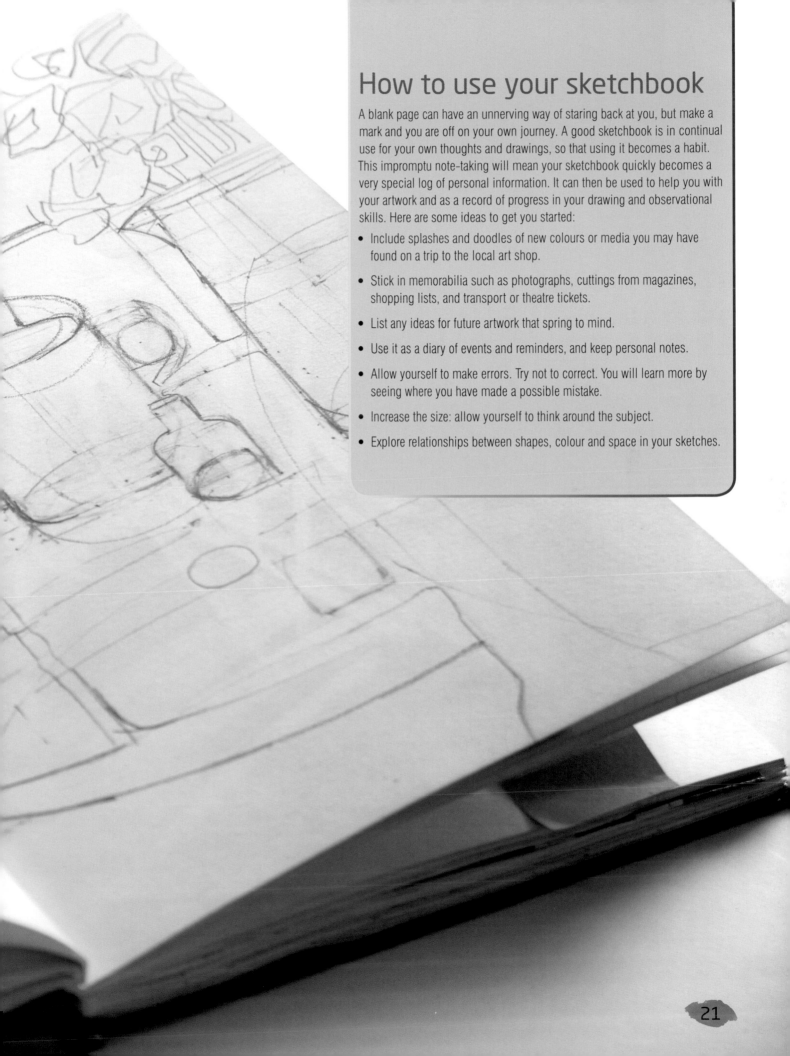

How to use your sketchbook

A blank page can have an unnerving way of staring back at you, but make a mark and you are off on your own journey. A good sketchbook is in continual use for your own thoughts and drawings, so that using it becomes a habit. This impromptu note-taking will mean your sketchbook quickly becomes a very special log of personal information. It can then be used to help you with your artwork and as a record of progress in your drawing and observational skills. Here are some ideas to get you started:

- Include splashes and doodles of new colours or media you may have found on a trip to the local art shop.

- Stick in memorabilia such as photographs, cuttings from magazines, shopping lists, and transport or theatre tickets.

- List any ideas for future artwork that spring to mind.

- Use it as a diary of events and reminders, and keep personal notes.

- Allow yourself to make errors. Try not to correct. You will learn more by seeing where you have made a possible mistake.

- Increase the size: allow yourself to think around the subject.

- Explore relationships between shapes, colour and space in your sketches.

Choosing a subject

Through constant observation and reaction to my surroundings, I aim to see the world in snapshots of colours and shapes. I take excitement from everyday occurrences such as colour and light playing on a building, the shapes created by passageways, or the amount of sky visible against a roofline. Making sketches of these snapshots helps me to work out whether something that catches my eye is worth pursuing as a painting subject.

Fundamentally, this is how I interact with my surroundings every day; and this is how I find the starting points for my painting. Even seemingly unpromising discoveries, like an abandoned chair amidst walls covered in graffiti, can be an exciting potential subject. My process tends to develop quick sketches made on the spot into more considered sketches that are specific preparation for a painting.

⟫⟫⟫ Thumbnail sketches

I refer to quick sketches which take ten to fifteen minutes to complete as thumbnail sketches. I recommend you keep them small – approximately 5cm (2½in) square or 8 x 12cm (3 x 4¾in) in size. If you contain these small images in a square or rectangular 'frame', it will give a clarity to your sketches, which makes them more useful visual information to use as reference for future work.

We tend to look at things rather than the spaces between them, but negative spaces are an important part of the way to see and think about what might make a successful drawing and then a painting. Try to bear the empty spaces in mind when making thumbnail sketches.

⟫⟫⟫ Preparatory sketches

The planning and the design of a composition for an artwork should be doodled and worked out in your sketchbook. However, a person's first sketch or drawing often outshines attempts to refine it. This is where the sketchbook becomes an important tool.

Your preparatory sketch for an artwork should take the best elements of the thumbnail sketches and create an image that you can use at full size on your watercolour paper. Try not to deviate too much from the thumbnail sketches and other preparatory work for your final piece or it may feel like you are starting again!

⟫⟫⟫ Taking notes

Notes about the work you are planning, such as observations on colour and form, will take on new potential as you make careful observations about them in your sketchbook.

Everything that surrounds you may have possibilities that you can use in your work. Read over your notes as you develop your preparatory sketches for the final artwork.

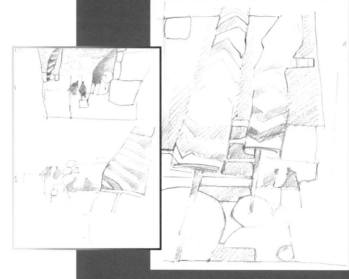

Thumbnail sketches
These thumbnail sketches were made while sitting in cafés and observing how passers-by interacted with each other and their surroundings. Travelling usually involves waiting for somebody or something to arrive – so sketching while on holiday or out and about is a valuable exercise.

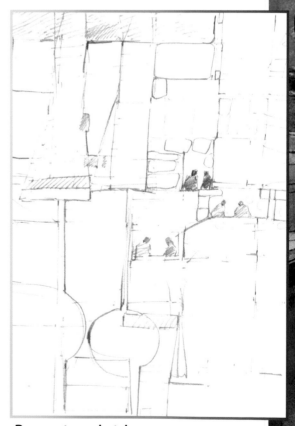

Preparatory sketch
This sketch was developed from the thumbnail sketches above, and then used as the basis for the final painting to the right.

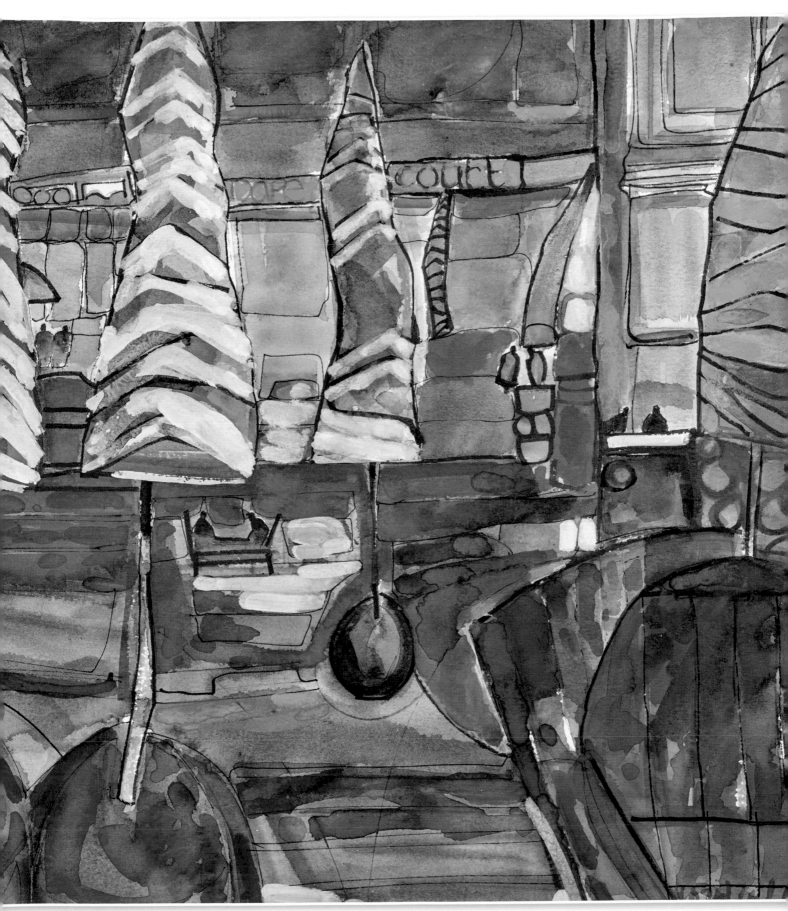

Santana Row

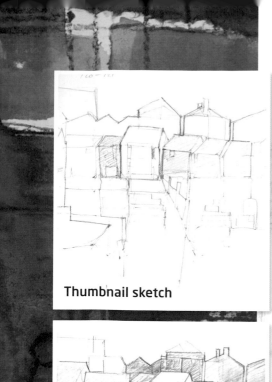

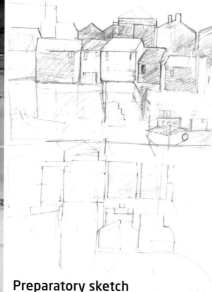

Thumbnail sketch

Preparatory sketch

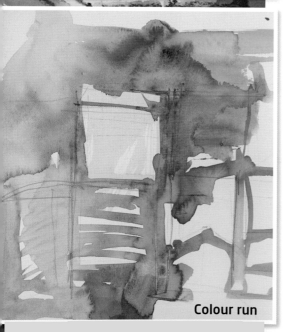

Colour run

Planning and composition

A successful painting is built on solid planning. These pages show an example of how I developed my work from a sketch into a successful finished painting. I started with a thumbnail sketch made during a visit to a seaside town (see top left). Harbours are places that often present exciting subjects for painting and offer multiple opportunities for drawing and painting.

⟫⟫ Line and shape

Developing a preparatory sketch from your thumbnail sketches revolves around the use of compositional rules such as the establishment of a focal point, and use of repetition of simple shapes and diagonals to help direct you into the painting. Simplification is key – both in colours and in shapes.

Compare the shapes in the thumbnail sketch with those in the more considered and developed preparatory sketch. Note that I have retained the continuous line that describes the negative space between the rooftops and the edge of the paper, and established one building as a focal point by retaining it in white while shading the surrounding buildings. The focal building is set slightly off-centre, and its lines contrast with the refined, straight lines of the rest of the image.

The steps of the harbour are described with quite strong diagonals and repeated horizontal lines in the thumbnail sketch. In the preparatory sketch, I decided to replace the diagonals with vertical lines to simplify them. If you do this, make sure you retain enough visual information for the viewer to read them as steps. Here, for example, a gradual increase in the spaces between the horizontal lines suggests that you are looking at steps. Likewise, the buildings are simplified into a combination of squares and rectangles made up of horizontal and vertical lines, while the roofline becomes a series of diagonals. These basic shapes combine to create the sense of a row of buildings, but reduce the visual complexity of the thumbnail original.

⟫⟫ Colour runs

My favourite part of the day is the early evening. The slowly dimming light gives deep shadows, colours become richer and a lack of light calms down unnecessary detail. This made the choice of colours an easy one – I would use colours that evoked the evening: Bengal rose, Winsor violet and Winsor blue (red shade) as my main colours.

I made a light copy of the preparatory sketch, then tested out the colours I wanted to use in a 'colour run' (see bottom left). Colour runs are similar to thumbnail sketches for colour, in that they are used for reference. For more information on colour runs, see page 40.

The colour run gave me an opportunity to see how the paints I intended to use would work together, and also let me experiment with how I would colour particular areas. For example; the bright yellows leading the eye towards the focal area worked well, so these were followed through into the finished painting. Once I had a basic idea of how the colours would work, I started on the painting proper – there is no need to overwork a colour run. Note how the colour intensity of the finished painting is much stronger and deeper. This was achieved through multiple overlaid layers.

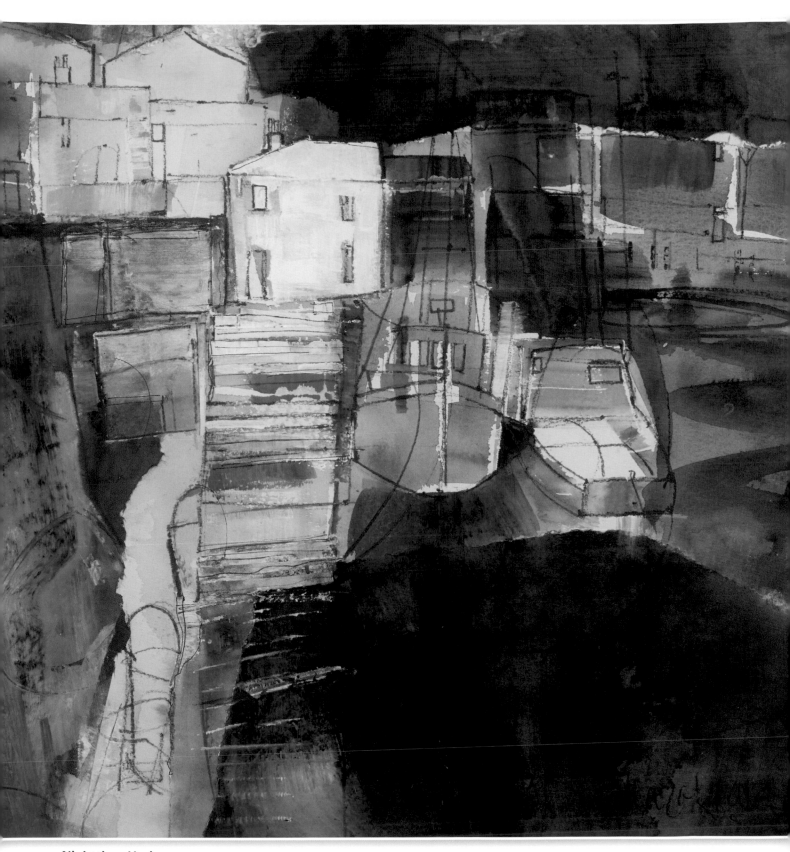

Nighttime Harbour

I often find a painting has an uncanny way of telling me to follow what is appearing on the surface rather than my initial planning. As long as I don't allow myself to stray too far, I am generally happy to let the developing painting inform my initial plans. This painting is an example of this process – thought through thoroughly, but evolving into something a little different as I worked.

COL

OUR

COLOUR & PAINT

Although a combination of colour and subject often come along hand-in-hand, the choice of which colours to use is one of the most important and enjoyable starting points for your painting. This is an exciting stage; with your sketchbook and notes to hand, you begin your decision-making on what palette of colours will give the best result.

Making choices

Choosing what paints to use in your painting depends on many factors, not least of which is your personal response to colour. There is no reason why specific colours have to end up in places where we expect them to be. You are free to paint and experiment outside accepted colour theory – and to be an artist who breaks a few rules to do something unexpected.

A lot of paints have arrived on my palettes by chance or recommendation from other painters. As I travel, I constantly observe how people in different areas of the art world choose to use colour. In my experience, warmer climes seem to encourage artists to go further with daring and amazing colour combinations, which I usually cannot wait to try out in my own work.

The process of noticing and assimilating how a colour is being used in different industries and art movements can take a considerable length of time, but do continue to experiment and allow new colours to find their way onto your palette.

Qualities of colour

Choice of colour is very personal, and advice on colour theory is boundless. Personally, I prefer to work instinctively, picking colours by hue and impact rather than through scientific principles or by name. Ultimately, if I like a paint colour and it responds well, I will make it part of my palette of colours. With that said, there are some useful definitions which can help guide you in making your choice.

Hue The fundamental aspect of a paint, hue describes the specific colour. Even though they are both blue, French ultramarine is a different hue to cobalt blue, for example.

Temperature Colours can be divided into 'warm' and 'cool' pigments. Warm colours are eye-catching (and generally have some red pigment in it), while those with more blue are described as 'cool'. Winsor red is a warm red, for example, while alizarin crimson is a cool red. One way to make a start in your choice of colours is to choose a warm and a cool of each primary: i.e. red, blue and yellow.

Tone This describes the relative light or darkness of a colour. Winsor lemon, for example, is a light-toned yellow paint, while yellow ochre is darker in tone. The prevailing tone in a painting is sometimes described as its 'key'.

Impact The most exciting colours that really make me want to paint are the ones that are vibrant and dominant. The correct term for this colour intensity is 'chroma'. Many newer synthetic colours are very intense when compared with traditional mineral-based pigments and I find these particularly exciting. Another way to add impact is by using pairs of complementary colours: those opposite one another on the colour wheel.

Autumn Barns (top) and Early Morning Light (bottom)
These two paintings demonstrate some of the qualities of colour.

Autumn Barns makes a strong statement in warm colours and bold hues. The overall tone is relatively dark, but note the careful use of small contrasting areas of lighter tone, which creates eye-catching details that ensures impact.

In contrast, *Early Morning Light* demonstrates a high-key scheme made up mainly of cool hues, with a warm focal area to provide contrast and interest. This gives the painting an overall ethereal feel.

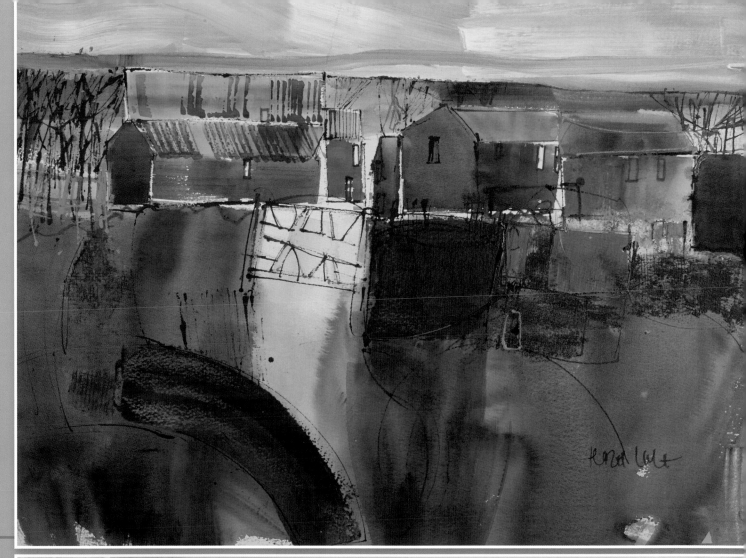

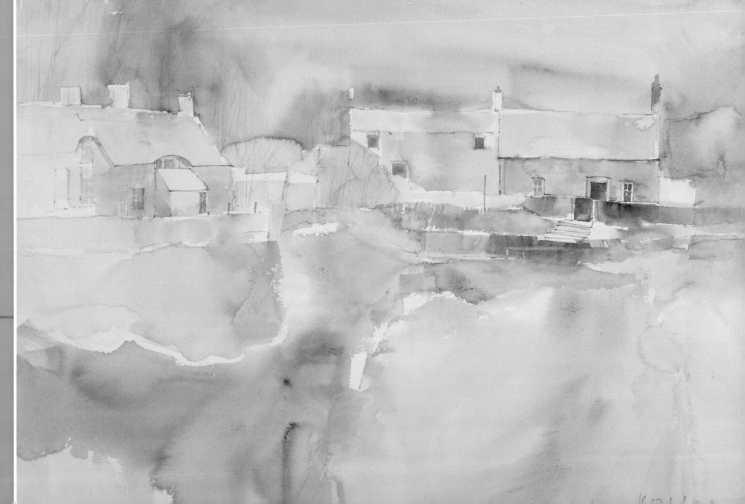

My palette

The following list of paints forms the core of my colour palette.
I occasionally add to it, but these colours will provide
a good starting point.

Light paints (palette 1)
Lemon yellow, Winsor lemon, Indian
yellow, and Winsor orange.

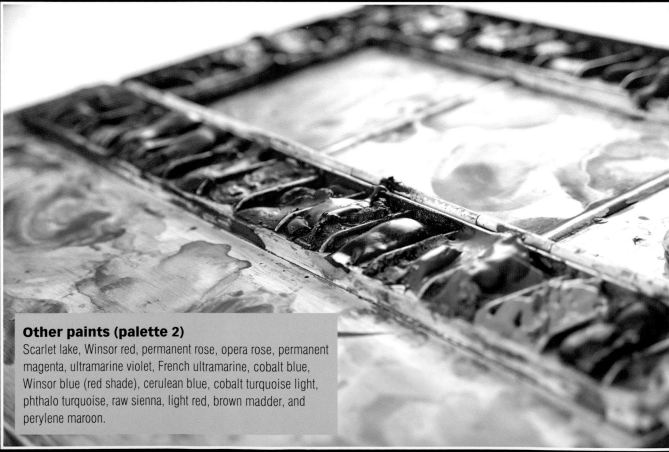

Other paints (palette 2)
Scarlet lake, Winsor red, permanent rose, opera rose, permanent
magenta, ultramarine violet, French ultramarine, cobalt blue,
Winsor blue (red shade), cerulean blue, cobalt turquoise light,
phthalo turquoise, raw sienna, light red, brown madder, and
perylene maroon.

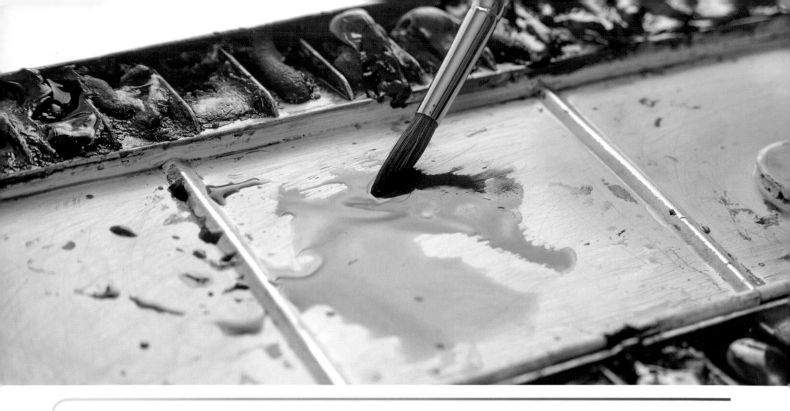

USING WATERCOLOUR

Paint consistency

Getting the paint consistency right is something that is best learnt through practice and experimentation, until it becomes an unconscious part of the painting process. The consistency you need will vary depending upon the effect you wish to achieve. Generally, I start with thin watery washes of paint (as shown above), then gradually increase the consistency for increasingly finer detail as the painting progresses.

To make large washes of diluted colour that can cover a large area of the painting surface, add a relatively large amount of water to your paint. Using less water and more paint pigment reduces the amount of paper you can cover and the result will also be a little less transparent. If you add only a tiny amount of water, the paint will stay where you place it on the paper surface, giving you more control. Note that all colour pigments will appear lighter in colour when you add a certain amount of water.

Order of work

I usually start painting with a large brush which allows me to quickly cover the shapes and spaces – a size 16 round sable watercolour brush for smaller paintings, or a soft-haired 50–75mm (2–3in) flat brush for larger ones. I use a brush large enough to carry sufficient colour to make clean-edged strokes across the painting in a single motion. Once the washes of colour are in, I use the point or thin 'blade' of the edge to make sharp lines or put in detail. Both of these brushes will fill the spaces and shapes with ease – only when I have almost completed the painting do I pick up a smaller brush for small shapes and details.

MANY WAYS TO USE WATERCOLOUR

These pages look at the way I use watercolour paint. However, this approach is not the be-all and end-all. Rather I know how to make this work without it looking messy and hesitant.

One of the most difficult concepts to avoid when starting to paint is the idea that there is just one right way to paint. There are many ways of using this medium and I encourage you to experiment and find your own path to success.

Observing the watercolours of master artist J. M. W. Turner will reveal both the clarity and risk-taking he used with his approach to this medium and demonstrate that every artist has permission to break the rules and try a new approach.

Mixing paint

It is easier to darken a mix than it is to lighten it, and combining more than two or three paints when mixing a colour can easily result in muddy, dirty mixes. For these reasons, watercolour is usually worked from light tonal values to dark, and starting with the lighter-toned colour when mixing paints together will help to keep your mixes clean and vibrant.

When it comes to mixing colours, place the coloured pigments side by side on the palette and slowly draw small amounts of the different colours into the middle to create a puddle of mixed watercolour. Try not to add colours straight into the middle of this puddle – this way if it all goes wrong at least you have not lost all of the particular paint mix. A palette that has a large flat surface will give you enough space to mix clean and vibrant colours.

In the example below, I mix Winsor lemon with cobalt turquoise to make a vibrant green. Note that instead of mixing all the paint together into a uniform hue, I keep some of each colour pure in the palette, combining them in the central area between the two areas of colour. This approach means that I have access to a full range of the mix, from pure Winsor lemon to pure cobalt turquoise, taking in every hue of the green on the way. Leaving part of the original colours showing also allows me to identify each colour used in the mix if I am need to make more, or recreate it in the future.

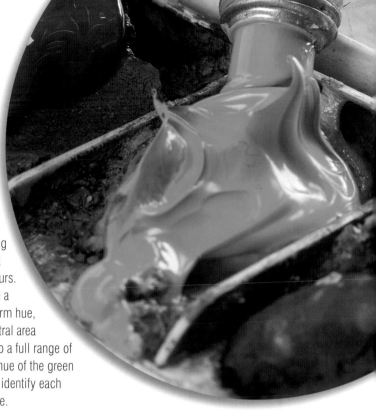

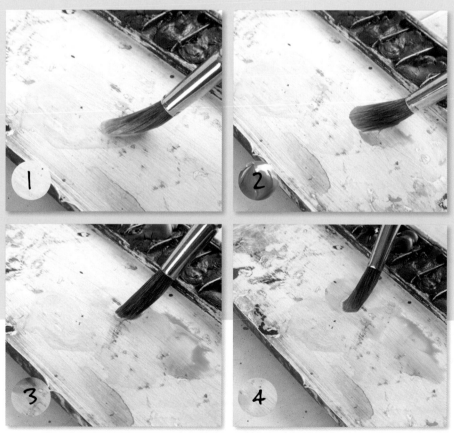

1 Wet a size 16 round brush and pick up a reasonable amount of your first colour, then place it in the palette.

2 Rinse out the brush in clean water then pick up the second colour. Place it in the palette to the side of the first colour.

3 Draw the colours together on the palette, leaving some of the pure hues clean at the edges.

4 Gently encourage the colours to mix by drawing more of each paint in from the edges, rinsing your brush in clean water and adding more of each paint if necessary.

CHECK YOUR MIXES

Before using the mix on your artwork, add a dab of your colour mix to a spare piece of paper to check whether you have arrived at your intended hue.

Choosing and using your colours in a painting

The colours you choose for a particular painting can affect the mood, impact and, ultimately, the success of the finished artwork. When starting out on a new painting, it can be tempting to simply use all the paints you own in the hope of producing a bright, vibrant artwork, but it is more likely to create a muddy result. Picking up colours without careful thought and dotting about using a wide variety of hues can prove problematic and result in an incohesive painting. Restricting the colours you use will help to make sure your paintings have visual impact.

The chances are that you already have a good sense of which colours sit well with others, but if you are uncertain, the following pages look at some example paintings and the palettes I used. They offer some different approaches you could try for choosing colours for your own work. These tried-and-tested palettes can be used as starting points for your own choice of colours.

Colour and colour theory have now become concepts I no longer have to consciously think about. Instead, I let my intuition take over, and I encourage you to do the same. Perhaps most importantly, allow yourself to make mistakes through trial and error – it really is no fun to stay within the confines of a 'safe' familiar colour range.

⟫⟫ Dominant and supporting colours

Selecting a scheme with one dominant colour and one or two supporting colours will give a cohesive result and make things simpler for you when painting. The dominant colour is usually one that covers large areas of the finished painting or is repeated in different shapes. In order to prevent the painting becoming too monotone, using some supporting colours that complement or contrast with the dominant colour are important. For example, if your dominant colour is blue, then you might pick its complementary, orange, as one of your supporting colours.

The simplest way to pick the colours for your painting is to look at the subject in front of you and let it suggest your first, dominant, colour, then pick supporting colours that go well with it. If it is not possible to see the subject directly, picking just two or three main colours with which you are familiar is a good starting point. Remember – using fewer paints will make it easier to get the balance of colours correct.

Cool palette

This painting uses mainly cool colours. The result is a calm painting, but dashes of hot pinks and reds prevent it looking downbeat or muted. Scarlet red on the café sign and pink in the sky add strength and warmth through the whole painting.

Opposite:
Blue Saratoga

Dominant colours
Cobalt blue, cobalt turquoise light, and Winsor blue (red shade).

Supporting colours
Winsor lemon, Bengal rose, vermillion, and brown madder.

34

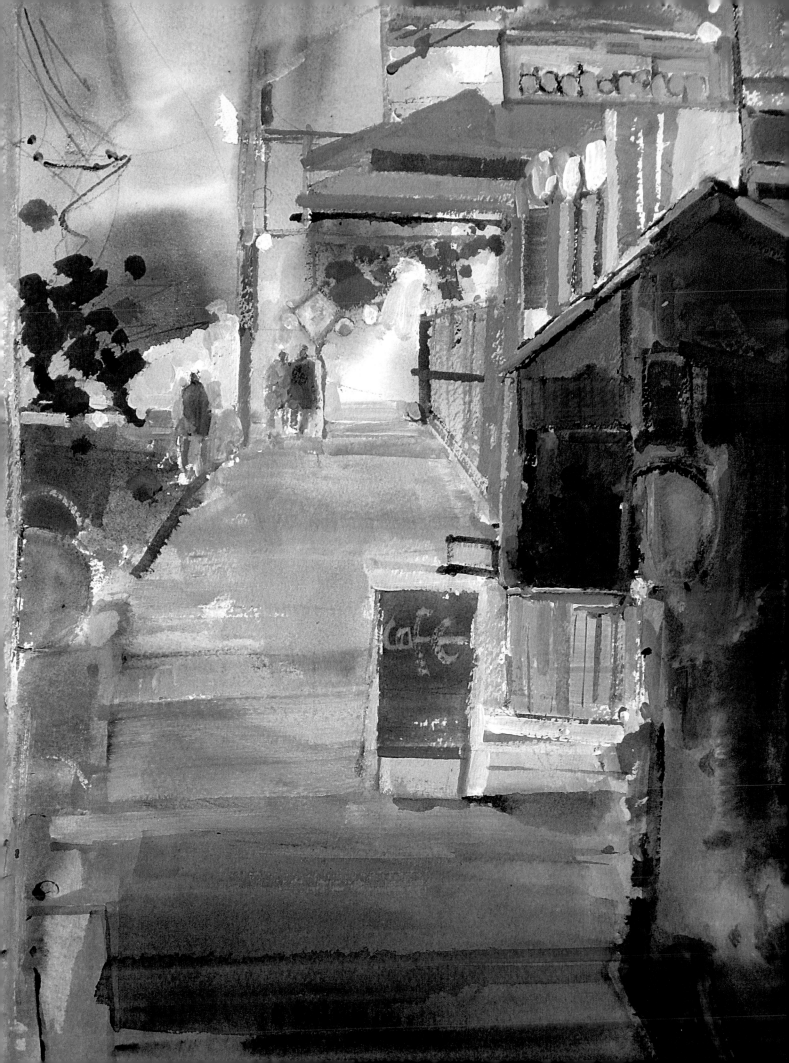

Warm palette

Warm colours catch the eye and seem to bounce forward towards the viewer, while cool colours seem to recede in the image. This can be used to create an impression of distance, and to move the viewer's eye around the painting in the way you decide. Maximum impact can come from real extremes, using the white surface of clean paper against densely applied rich paint, like the red in this example.

This palette uses three bold warm paints as the dominant colours, also. In addition to these, I also used some other cooler supporting colours sparingly. These help to avoid the painting becoming monotone – and the cool blue touches serve to make the reds appear even more warm and vibrant by contrast.

This painting also demonstrates another option: that of diluting the paint to add variety in tone, rather than hue. Pick up lots of pigment and relatively little water for your dominant colour, but dilute the second colour choice down with lots of water. This will give it a lighter tonal value that helps it sit alongside the dominant colour, regardless of hue.

Dominant colours
Scarlet lake, Bengal rose, and Winsor orange.

Supporting colours
Winsor lemon, cobalt turquoise light, and brown madder.

Evening Barn

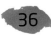
36

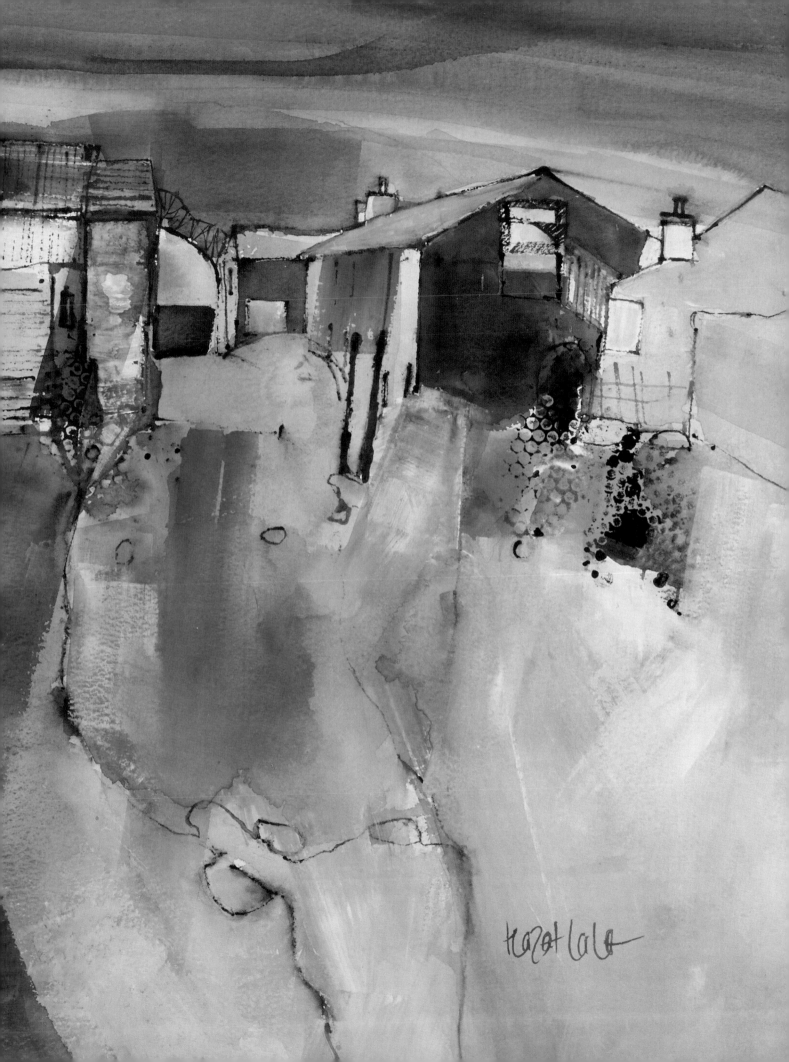

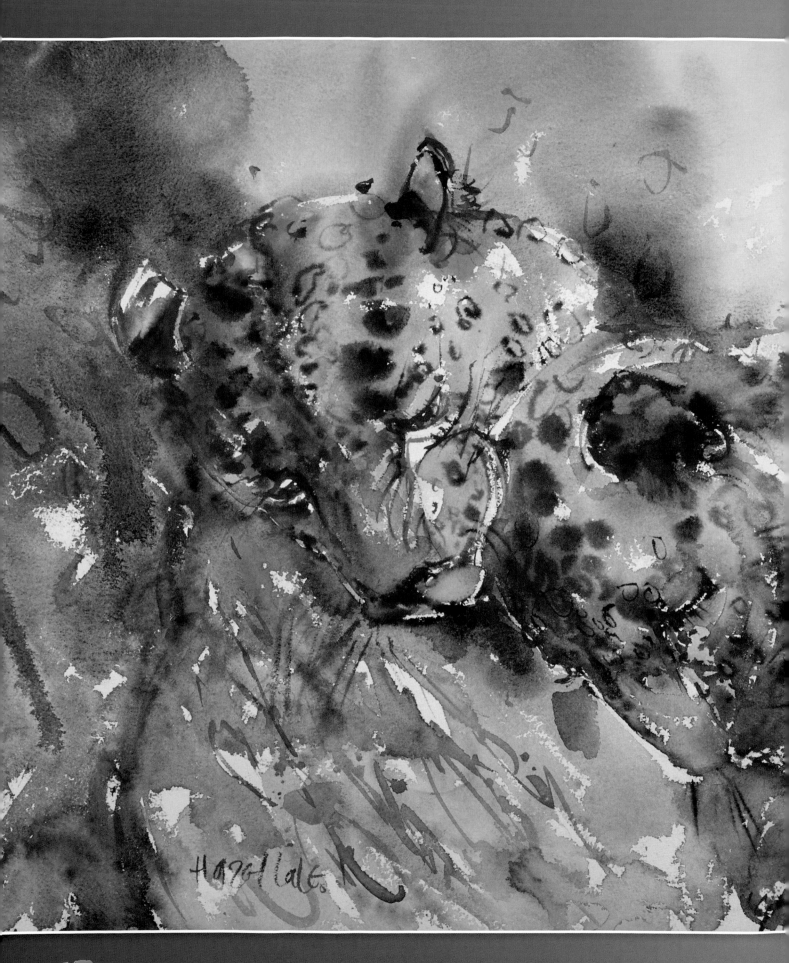

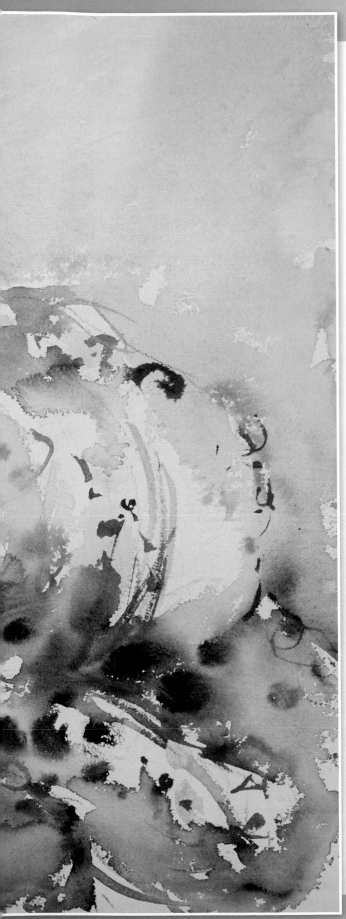

Balanced palette

This painting demonstrates how allowing colours to mix on the surface of the paper can give beautifully vibrant and subtle results, even when the overall palette is relatively balanced – that is, when no one colour is emphasised and instead colours are used from across the spectrum. This example uses red, blue and yellow as equally dominant colours.

Washes of Winsor lemon and Winsor blue (red shade) were combined wet-into-wet to give a variety of warm and cool green washes. Similarly, combinations of Winsor orange and Bengal rose resulted in the complex and variegated peach-orange effects seen here. Winsor blue was used to provide deep washes and glazes without making the painting dark and opaque – as the complementary colour to the yellow-orange used for the focal snow leopards, the blue background makes the leopards 'sing out' of the painting with vibrancy. Note also that blue-tinged Winsor violet has been used to add the distinctive spot patterns of the cats' fur.

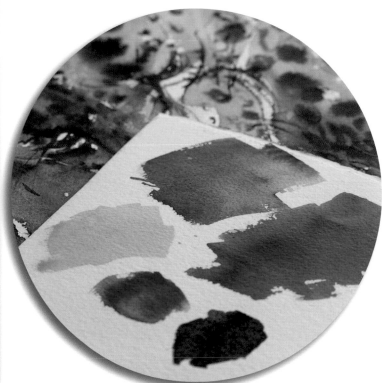

Dominant colours
Winsor lemon, Winsor blue (red shade), and Winsor orange.
Supporting colours
Bengal rose, and Winsor violet.

Snow Leopards

COLOUR RUNS

It is easy to play it safe with painting – no-one wants to ruin a piece of work with a technique or colour that might not work. However, always exercising caution over courage can take away the excitement of discovering a new idea or how the paint reacts when you are pushing it around. This natural hesitation can be quite a hurdle to overcome, and so experimentation is always a good idea. It can calm your nerves and helps confirm whether an idea might work or not turn out the way you want.

'Colour runs' are experimental run-throughs to test colour schemes. Colour runs can be made on small details or reduced versions of your sketch, as shown to the right here. These small runs are very fast to paint, and quickly reveal whether a colour scheme will work without fully committing to the final artwork.

Colour runs can also be made on full-size copies of your initial sketch. While these may take a little longer than the smaller examples – perhaps two or three hours – they are still a fast way to check that the colours maintain their impact at the final scale.

These larger and more involved colours runs offer you the chance to familiarise yourself with the composition and structure of the piece. This will help to build your confidence when you come to tackle the final piece. Crucially, this stage may help you with further refinements, moving your painting further from your source photographs and making it more truly your own interpretation.

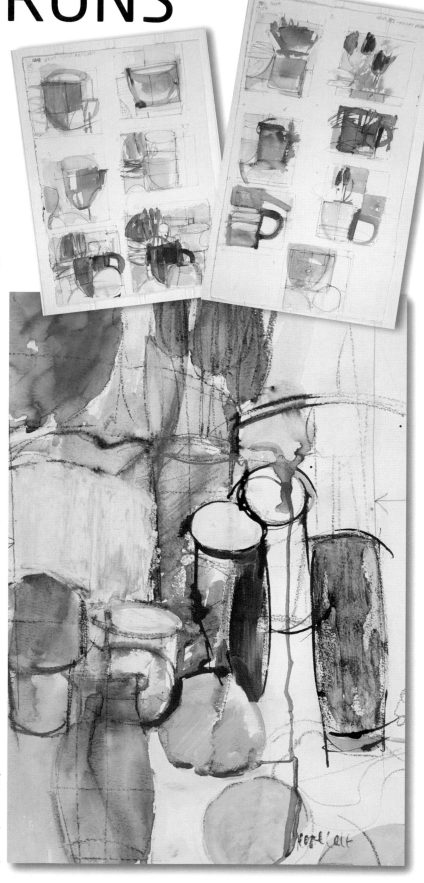

The small colour runs on this page were valuable in trying out lots of different colour schemes. Once I found one I particularly liked, I tried it out on a full-size copy of the sketch, which can be seen on the opposite page. This larger colour run included mixed media techniques.

These colour runs were all used to inform the final painting, which can be seen on page 113.

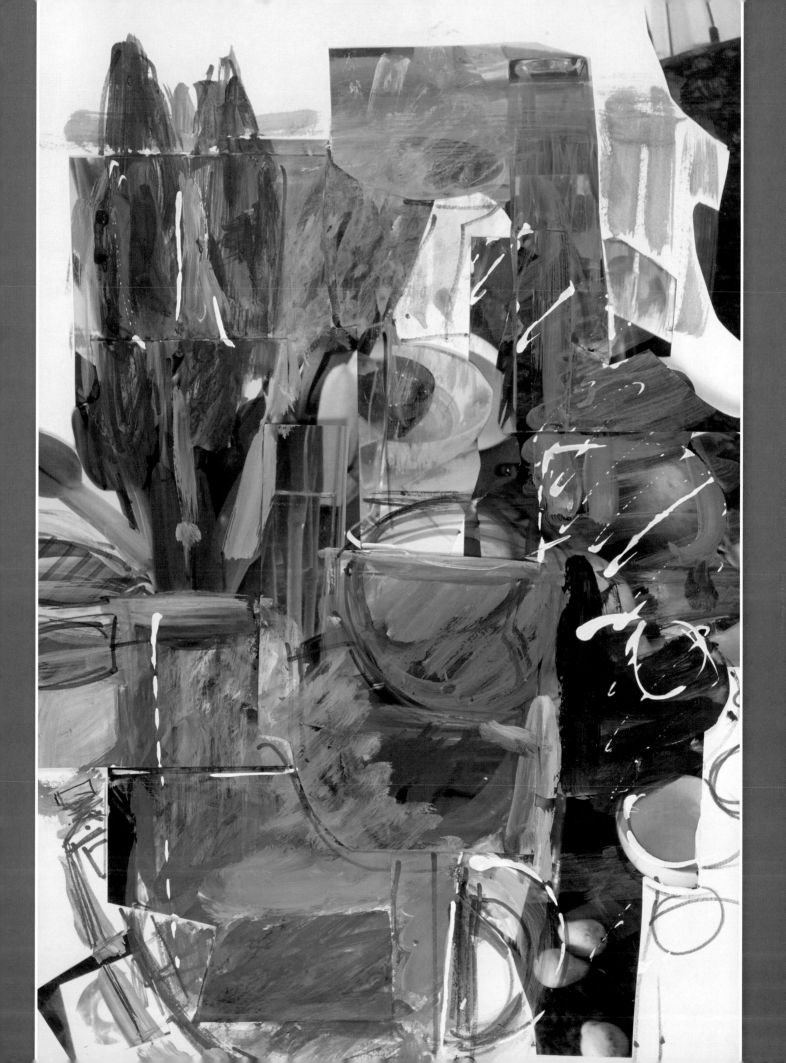

BOAT SCENE

It can be tempting to attempt complex compositions overflowing with multiple colours and shapes, but sometimes it is the simplest of scenes that result in the most exciting paintings. Drawing too much can take away your enthusiasm for painting as you begin to feel constrained, while adding too little information can make painting feel stressful as you are constantly looking for helpful guidance.

This step-by-step demonstration shows how to strike the balance between complexity and over-simplicity.

You will need

- Watercolour paper, 640gsm (300lb) rough surface, 56 x 76cm (22 x 30in)
- Watercolour paints: cobalt turquoise light, Winsor lemon, brown madder, Winsor red, Bengal rose (gouache), Winsor blue (red shade), Winsor violet
- 4B pencil and eraser
- Sketchbook
- Brushes: 50mm (2in) synthetic flat, Size 10 round

TIP

Try squinting at the scene in front of you to reduce the detail you can see as you sketch. This will often help cut out extraneous shapes, lines and colours to make composition easier.

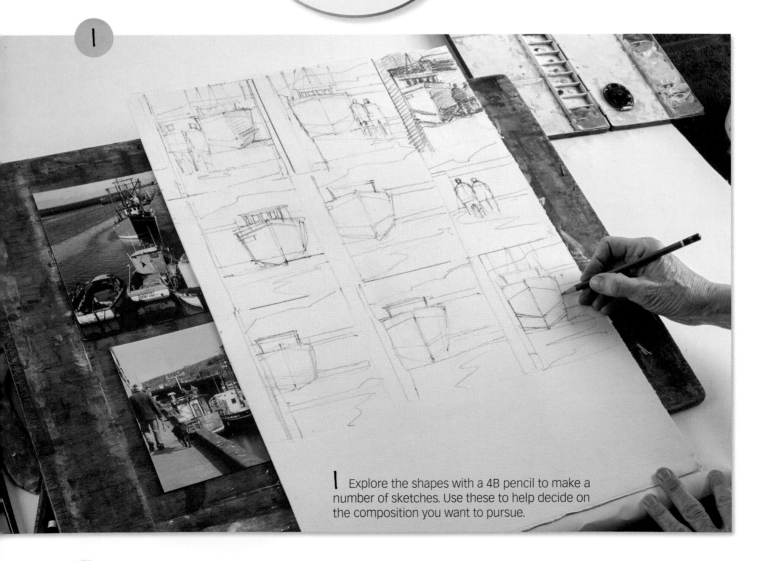

1

1 Explore the shapes with a 4B pencil to make a number of sketches. Use these to help decide on the composition you want to pursue.

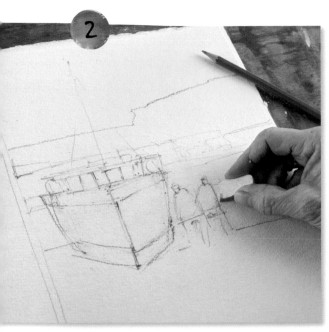

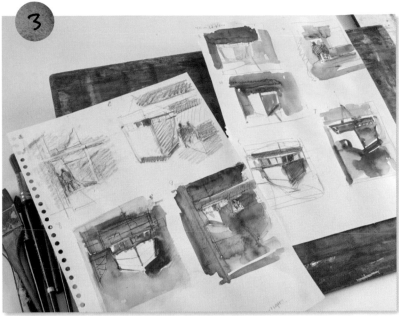

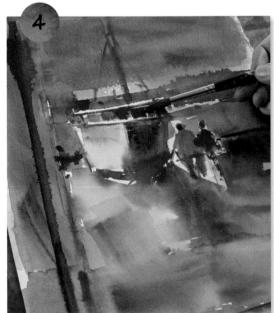

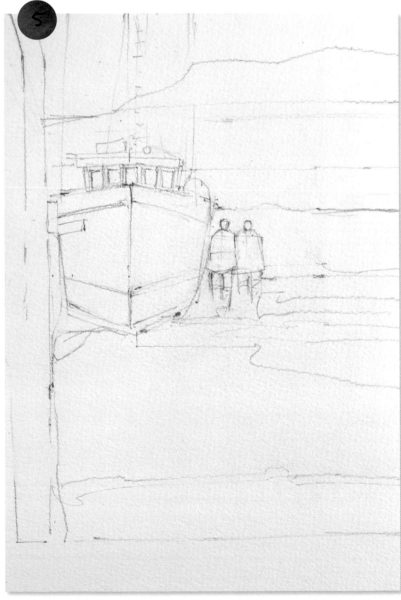

2 Once you have made a decision, draw the initial sketch at full size and adjust the details until you are happy.

3 Make some colour runs to try out different colour schemes and to familiarise yourself with the structure of the piece.

4 Make a large colour run to try out your favourite colour scheme on a full-size copy of the sketch. Pay attention to see which areas you find you need more guidance, and which seem over-detailed.

5 Make your final sketch using a 4B pencil, using the earlier preparatory work for reference, adjusting the complexity with help from the colour run.

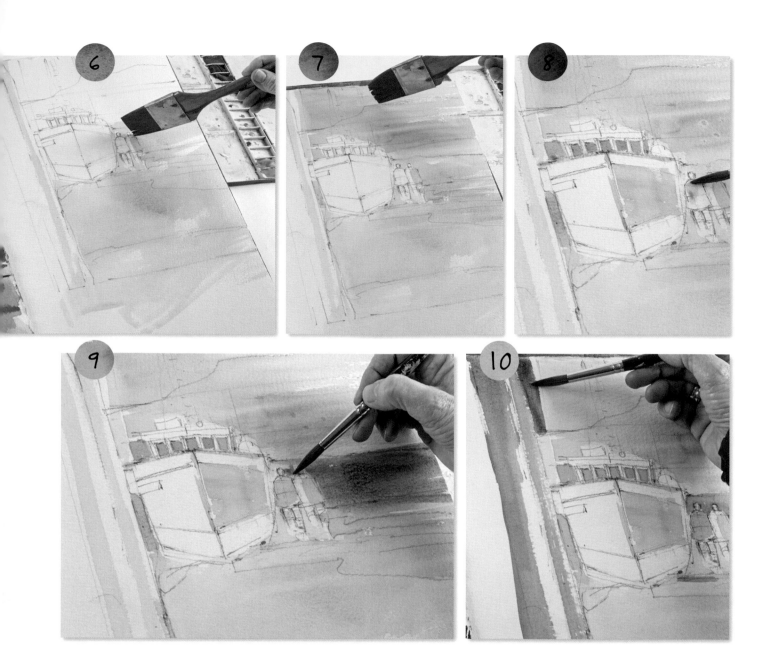

6 Use the 50mm (2in) flat brush to paint the foreground sand areas and building with dilute Bengal rose. Use the corner of the brush to work around the figures.

7 Add Winsor violet and Winsor blue (red shade) to the mix and paint the sky with broad horizontal strokes.

8 Continue mapping out the colours, adding Winsor blue (red shade) on the boat and figures. Change to a size 10 round brush for finer details such as the window.

9 Add brown madder wet-in-wet to the distance, swapping between the 50mm (2in) flat and size 10 round brushes.

10 Use a mix of Winsor violet and Winsor blue (red shade) for the dark shadow on the building. Add brown madder for variety, then allow the painting to dry before continuing.

11 Add another layer of Bengal rose over the sand using the 50mm (2in) brush, introducing brown madder, Winsor lemon and a hint of Winsor red wet-in-wet.

12 Paint the sky with Winsor blue (red shade) and add Winsor violet wet-in-wet. Dilute the mix and reinforce the boat.

13 Add some touches of Winsor lemon to the foreground area.

14 Deepen the shading on the boat using the size 10 round brush to apply a mix of Winsor blue (red shade) with a little brown madder. Do the same on the left-hand building with Winsor red and cobalt turquoise, and on the boat's hull with a mix of brown madder with cobalt blue.

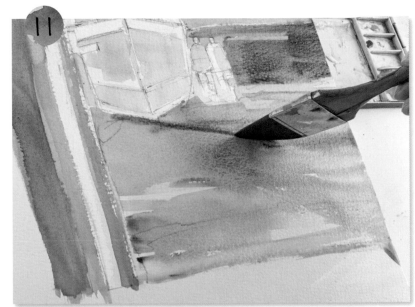

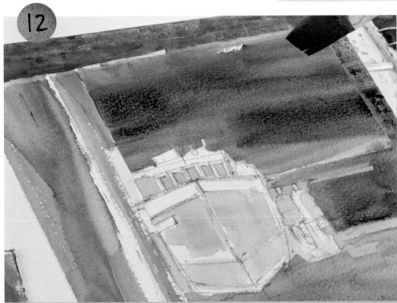

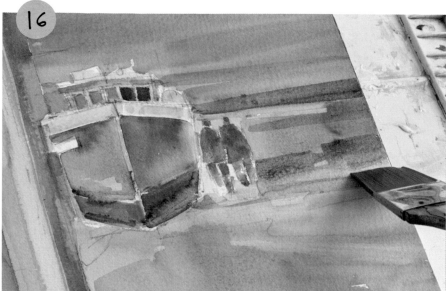

15 Develop the boat and paint the figures using cobalt turquoise light, Winsor blue (red shade), Winsor violet and brown madder, applying the paint with the size 10 round brush.

16 Add cobalt turquoise light to the remaining white areas of the boat and add a streak across the ground level at the figures' feet.

17 Develop the dark areas across the painting by overlaying areas of shadow with further layers and touches of the base colours: Winsor blue (red shade) in the sky, Bengal rose and Winsor red in the sand, cobalt blue and Winsor blue (red shade) on the boat, and brown madder and Winsor blue on the figures. Allow the painting to dry before continuing.

18 Paint in the mast using brown madder, applying the paint using the point of the size 10 round brush, then draw the lines of the rigging with Winsor blue (red shade).

19 Add any final details to the boat and figures using the mixes on the palette and the size 10 round.

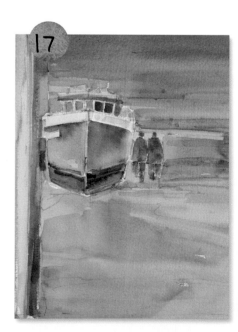
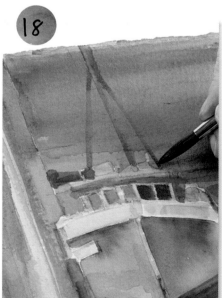
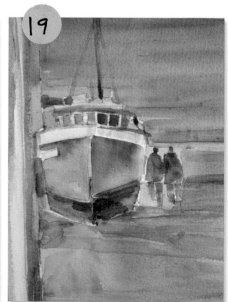

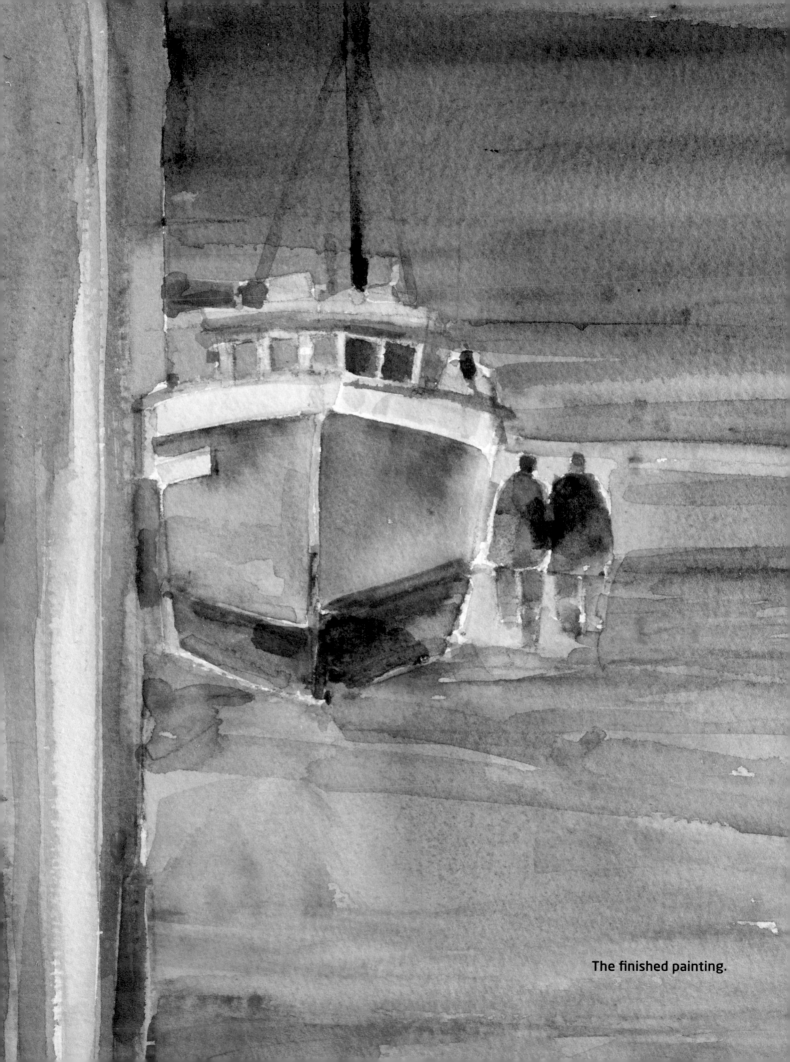

The finished painting.

BRINGING
PAINTINGS

YOUR
TO LIFE

LINE

Lines are usually the first mark we make to describe anything we observe and want to record. From thumbnail sketches to a complete graphic study for an entire painting, line forms the most basic part of our artwork.

Whether geometric or organic, lines can capture movement and strength. We have unconscious associations and reactions to lines, and understanding these can help to inform our artwork.

A good knowledge of the language of line will give you another way to bring energy and vibrancy to your watercolour artwork.

Top:
Horizontal line
The horizontal line implies a feeling of calm and stability and can suggest a horizon or ground level. By leaving some space between horizontal lines, a sense of distance can be suggested.

Middle:
Vertical line
Reaching out, steady strength, height; all associations we make with vertical lines. Upright and correct, they are often used in paintings to suggest buildings, tall trees and masts on boats. All give a strong contrast to the horizon line, implying stability and division.

Bottom:
Diagonal line
Diagonal lines are directional, which means they can lead the eye to important parts of the composition. They are the least stable of the three main types of lines. This quality can be used to create movement, depth and excitement in your paintings, and is at the core of suggesting a three-dimensional space on the two-dimensional picture plane.

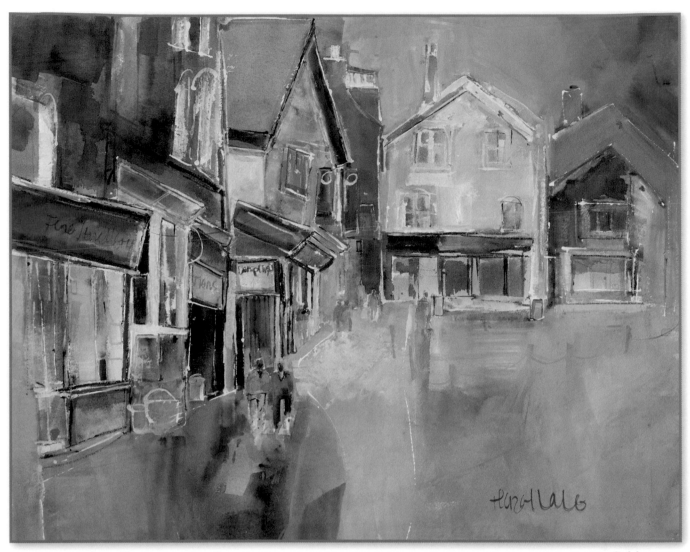

What do lines do?

Anything can be simplified into a series of lines, and they provide you with the framework to give movement and energy to your work. Imagine a vertical standing figure and a figure running at speed. The former will be made up of vertical and horizontal lines, while the latter's limbs and torso will be set at various diagonals, which creates a huge contrast in the type of movement. The former is calm and stable while the other is moving rapidly towards the edge of the picture plane.

Careful use of linework can also suggest an emotional response. Using soft, delicate lines will give the viewer a very different reaction to the bold aggression of acutely jagged lines – compare the curved lines of the figure on the near right with the frantic energy of the spiky figure on the far right.

Ashbourne
The diagonal lines on the left-hand side lead the eye into the picture and suggest perspective, while the verticals and horizontals used at the top and on the right-hand side suggest the stability of the buildings. This is a picture that suggests a safe, inviting space.

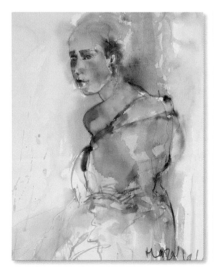

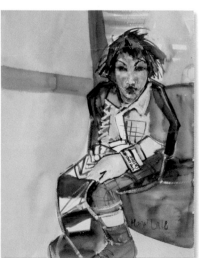

51

Line weight

Line weight and quality can suggest numerous ideas to a composition, one of which is dimensionality, or depth. Softer, lighter value lines, drawn with little pressure, imply more light and distance. For the same reasons, stronger, darker-toned lines that are applied with more pressure will appear to come forwards.

As an illustration, draw a line by pressing down onto your sketchbook surface using a 5B soft lead pencil to create a wide, dark line. Gradually reduce the pressure you are putting on the pencil as you continue the line to the end. When you reach the end, you will have achieved a continuous line that goes from dark in tone to light, which will have a three-dimensional quality.

The images on this page show how using a variety of line weight in your thumbnail and preparatory sketches can help to define areas and place them within the page space.

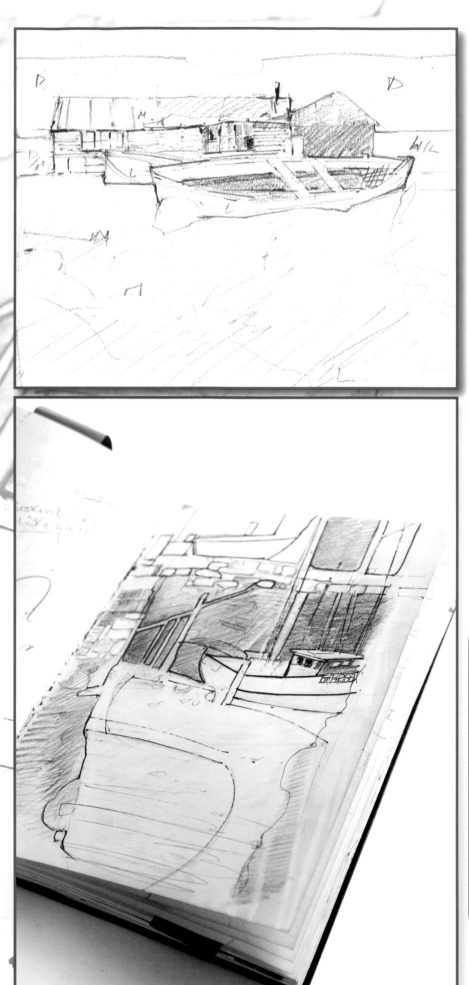

Opposite:

A Warm Afternoon

Line weight applies equally to your painting, though here line will likely be applied with the brush rather than a pencil.

Here, some of the foreground figures and the signage are treated with strong, heavy lines, which make them immediately eye-catching. This is because the lines suggest definite form and makes them seem active.

Compare the strong linework on these focal elements with that used for the seated figures, which is light and indefinite. As a result of the contrast, the seated figures seem to fade into the background somewhat, where they act as supporting elements rather than competing with the focal parts.

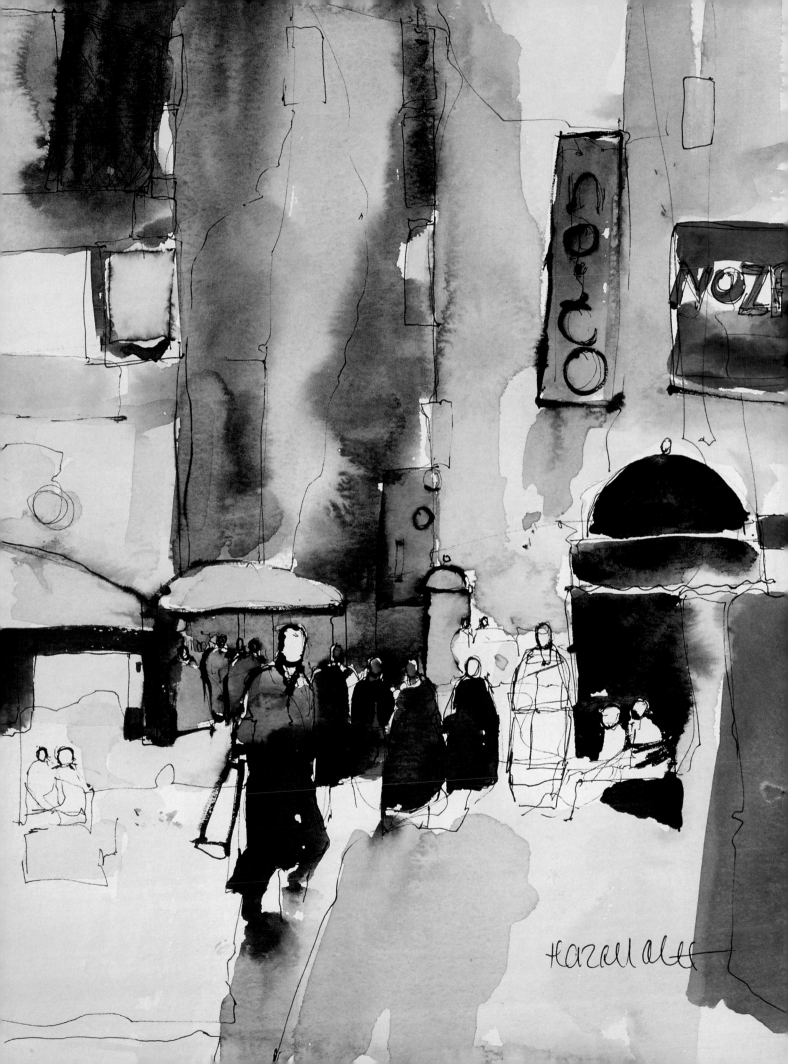

SHAPE & FORM

The most basic components of picture-making are shapes. Everything we look at can be broken down into the simple shapes which are the building blocks of every drawn image. The way in which we combine these shapes makes them recognisable as objects or spaces, and creates their form on the paper.

Fundamental shapes

The fundamental shapes are the square, the triangle and the circle. All other shapes are ultimately variations or combinations of these – a rectangle is an extended square, for example, while a simple house might be represented by a square with a triangle on top.

The ability to identify simple shapes and how they relate to one another helps simplify our approach to drawing. Whether organic or architectural, complex shapes can always be broken down into their component fundamental parts.

The fundamental shapes are also useful for helping to compose your drawing. If you arrange different elements so that they sit at the points of a triangle, for example, the viewer will follow the invisible lines between the points. The diagonal lines of a triangle are directional, and so arranging the focal points of the image like this will move the viewer's gaze from point to point.

Look for the fundamental shapes in these buildings.

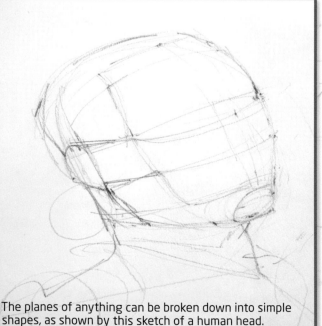

The planes of anything can be broken down into simple shapes, as shown by this sketch of a human head.

An example of a triangular composition. The fundamental shape is not drawn out, but the lines of the elements in the painting follow its shape.

Square

With four sides of equal length, the square is a shape that conveys solidity. A rigid form, squares form eye-catching blocks in your artwork, slowing or stopping the viewer's gaze. For this reason, they make good framing shapes for focal points.

Triangle

Whether the sides are equal or different in length, this is the only fundamental shape that conveys movement, as it is the only one that implies direction.

Circle

A circle will sit inside a square, with the edge touching all four sides. This can be a way of introducing softness to hard-edged shapes.

Other shapes

All other shapes are essentially variations on the three fundamental shapes shown here. Rectangles like this one are extended squares, ellipses are distorted circles and so forth. Breaking up complex forms by identifying the fundamental shapes that make them up will help you to simplify your work.

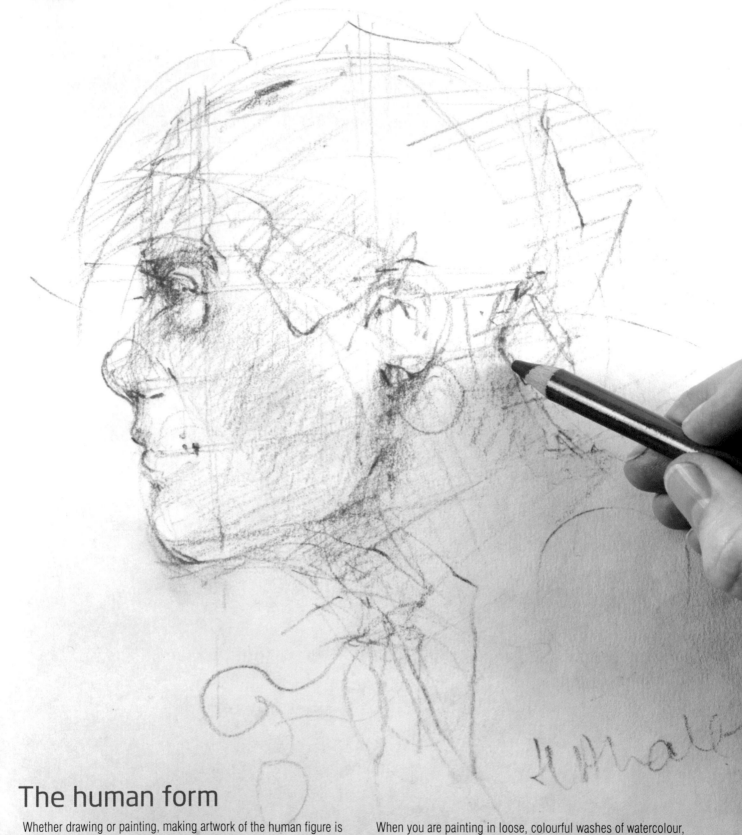

The human form

Whether drawing or painting, making artwork of the human figure is an enjoyable challenge and one of my favourite things to do. The face is almost invariably the focus of a painting of a figure and so an understanding of the construction of the head of the figure is all-important. The shape of the skull informs the curves, hollows and flat planes of the head and face. Careful observation of these shapes will help you structure the form of the head correctly, which in turn will help you paint the colour washes in the correct spaces.

When you are painting in loose, colourful washes of watercolour, there has to be a strong anchor point to prevent the painting from becoming an indeterminate jumble of colours and lines. Before attempting any portrait or figure, I draw multiple contoured sketches of the figure I am about to paint. This gives me confidence to be accurate and loose with the final drawing, and bold with the colours I choose to paint with.

Form and tone

Paper is a two-dimensional surface. To create the impression of depth on it, we need to create the illusion of form through the use of tone. Tonal value ranges from pure white to an absolute black. This gives lightness or darkness to a drawing or painting. Gradations of this value within a shape can be used to create the illusion of depth.

Experimenting with light can add to the drama to a painting. Hot sunny days will create warm, dark, positive shadows. In a moderate light, shadows will have less contrast but the theory is still there.

Hatching and cross hatching – making a series of parallel lines on a shape – are one way of achieving an area that implies tonal changes without altering the pressure you exert on the pencil. In this instance the line keeps the same tonal weight but by crossing it repeatedly with other lines it increases in tonal value suggesting greater depth.

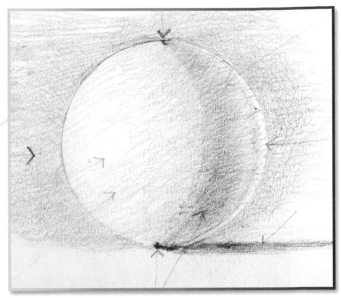

Hatching and cross hatching have been used on this sketch to create darker areas of tone. These create the illusion of three-dimensional form on the two-dimensional shape, making the circle appear to be a sphere.

Contrast

A picture with great contrasts can create intense focal points – a light sky against a strong dark foreground, for example. The sketch to the right shows how areas of light and dark placed alongside each other stand out and catch the eye more than adjacent areas of midtone.

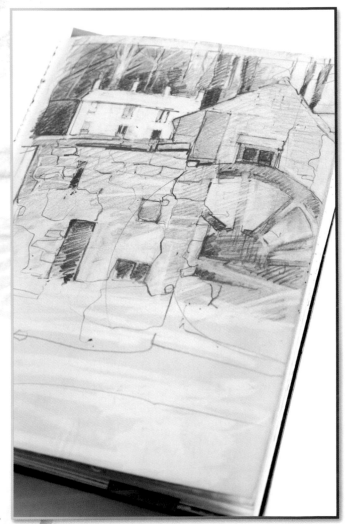

Form
The forms of the buildings, mill wheel and architectural details like windows and stonework are made clear here, through a combination of line and tone.

White space and counterchange

Correct use of tone helps to create drama and interest in your artwork. A drawing or painting made with the correct amount of white space and eye-catching contrast in tones will be more striking than one with little contrast between the light and dark areas. Even seemingly mundane subjects can become interesting under certain conditions, such as when strong direct light is introduced. Strong light creates dark shadows where it does not touch, and eliminates more subtle details where it does, creating areas of 'white space', uncluttered areas which are important to give the viewer's eye somewhere to rest.

Counterchange is the transference of light from one surface to another. This effect helps to reveal the form of both the object and the parts of the artwork near to it, whether these are other objects or the background. This can be useful to bear in mind when you want to distinguish or blend together areas of your artwork.

The example sketches on this page show some examples of how forms are suggested or separated by contrast in tone and considered use of white space.

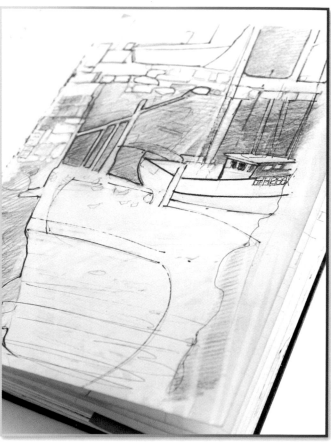

Counterchange

This sketch might appear over-busy if it were not for the large area of white space at the front right that provides an area for the viewer's eye to rest within.

Note that the contrast between the objects here is lower than that in the background, where the dimmer light provides less contrast between forms. This also helps to create the impression of distance.

White space

Many of the shapes here blend into one another, with no lines dividing them. This creates a semi-abstract impression that also simulates the effects of strong light and shadow. As with the sketch to the left, note that the large areas of white space contrast with the darker-toned areas; both help to define the others.

Continuous and broken lines

Not all objects need to be completely resolved in your artwork. You can add interest to forms by leaving them partly unworked. Leaving them unresolved lets the onlooker become involved as they search for the undescribed shapes that are suggesting forms on the two-dimensional space.

Including broken lines is one method of introducing uncertainty and interest to the viewer. Rather than drawing a complete outline round an object, leave some gaps and spaces. The viewer's eye will skip the gaps, create movement and energy in the painting and making them feel part of the action.

Another approach of getting into the work is by drawing using a continuous line: once you apply the pencil to the surface, do not lift it off until you have drawn all you want. This will mean drawing across otherwise open or empty areas to link objects, but this serves to reveal and release all sorts of unexpected shapes and spaces on the paper surface, which stimulates fresh ideas about the whole painting.

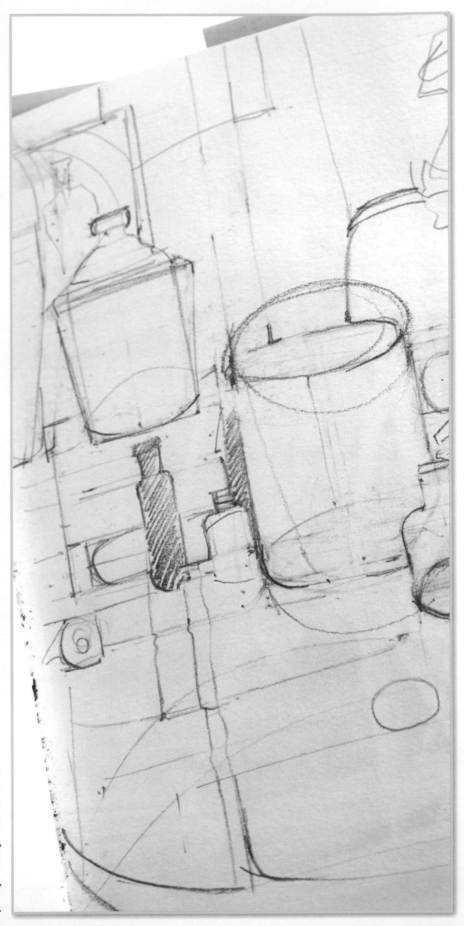

Linework
This sketch was started using the continuous line technique - note the lines that join and echo the main shapes on otherwise clear areas. I then refined the sketch with different line weights, leaving some lighter and reinforcing others that I wanted to draw attention towards. Still others were left absent, for the viewer to fill in themselves - an example of the broken line technique.

Exploring shapes through sketching

The following pages serve as an example of how line, tone, shape and form are used in producing a vibrant finished painting. This chimpanzee is an example of how you can create interest by contrasting three-dimensional and two-dimensional spaces.

⫸ Thumbnail sketches

Thumbnail sketches are an important part of the process of producing a painting. They enable you to find your way around a subject with line, discovering the parts that have caught your eye and, most importantly, help you to find the tricky bits before you start to paint.

My first sketch is shown above right. This initial exploration of the chimpanzee uses line to break down the organic shape into geometric shapes. Notice how and where variations on the fundamental squares, triangles and circles appear in the sketch.

Once I have drawn the overall shape and angle of the head it becomes relatively easy to place the facial features. The skull dictates where the mouth, nose and eyes are placed. A few construction lines around the facial plane help place these main features on the face.

⫸ Preparatory sketch

The image on the lower right shows a detail of the preparatory sketch made to work out the composition for the final piece (the full sketch can be seen on page 62) once I had explored the focal parts with initial sketches.

Here, the construction lines that show on the thumbnail sketch are mostly hidden, and some form is suggested through more use of tonal shading.

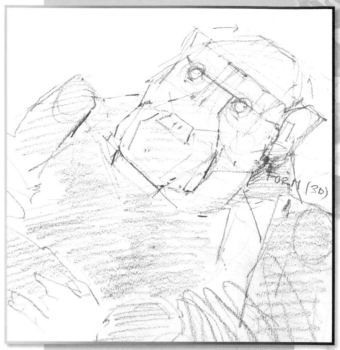

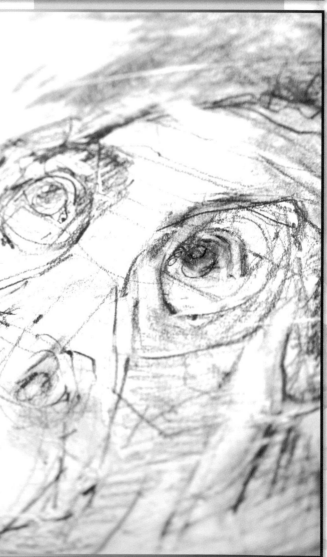

⋙ Exploratory sketches

While making your thumbnail and preparatory sketches, you may find some areas more challenging, or of particular interest. In these cases, it is a good idea to make some sketches to explore the area of interest in more detail. Working on elements in isolation – such as the features shown here – will help you concentrate on the specific challenges and opportunities of the area before beginning the final piece.

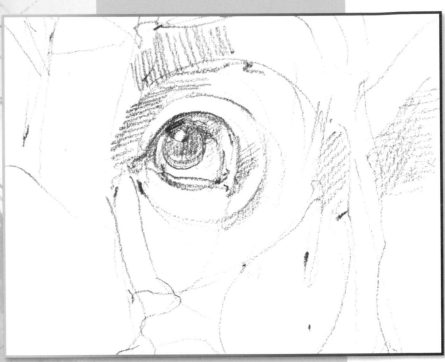

Detail of the eye

Eyes are always the main focus in studies of people and animals so making them believable and well-constructed is important. Note that I have included some tonal shading in my sketch here, as this is such an important detail to get right.

Detail of the mouth

While not quite as important as the eyes, the mouth and nose form another important focal point, and so warrant some extra detailed study.

Using your sketches while painting

I keep my sketches to hand and refer to them while painting, as they help to inform the process and head off any potential problems before they occur. However, the painting is far from a simple reproduction of the preparatory sketch.

In animals and humans there are some basic elements that are the same, one of which is the position of the eyes. These are seated on a horizontal line that is approximately in the middle of the facial plane. The eyeballs sit inside the eye sockets and, along with their defining shadows, become the main focal point in a forward-facing figure or animal. In the sketch (see below), the areas of shadow and highlight are rendered with hatching. In watercolour, paint marks are built up over dried initial washes to suggest the three-dimensional form. Eyes are always the main focus in studies of people and animals, so making them believable and well constructed is important.

The colours and shape that make up the head and face are quite dominant and so become the main focus. As a result, I made a decision to balance this strength with light-coloured, soft edges that are created by wet-into-wet washes. The latter makes for a less formal painting and helps the viewer to see the head and face first.

The length of the hands are suggested with line, but note that the hands are more defined in places and left loose in others. Leaving the lines unresolved allows the viewer to become involved as they search for the undescribed shapes, which creates interest.

Opposite:
Chimpanzee

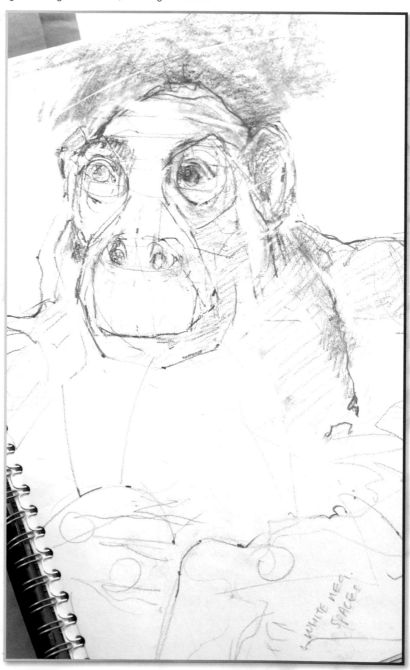

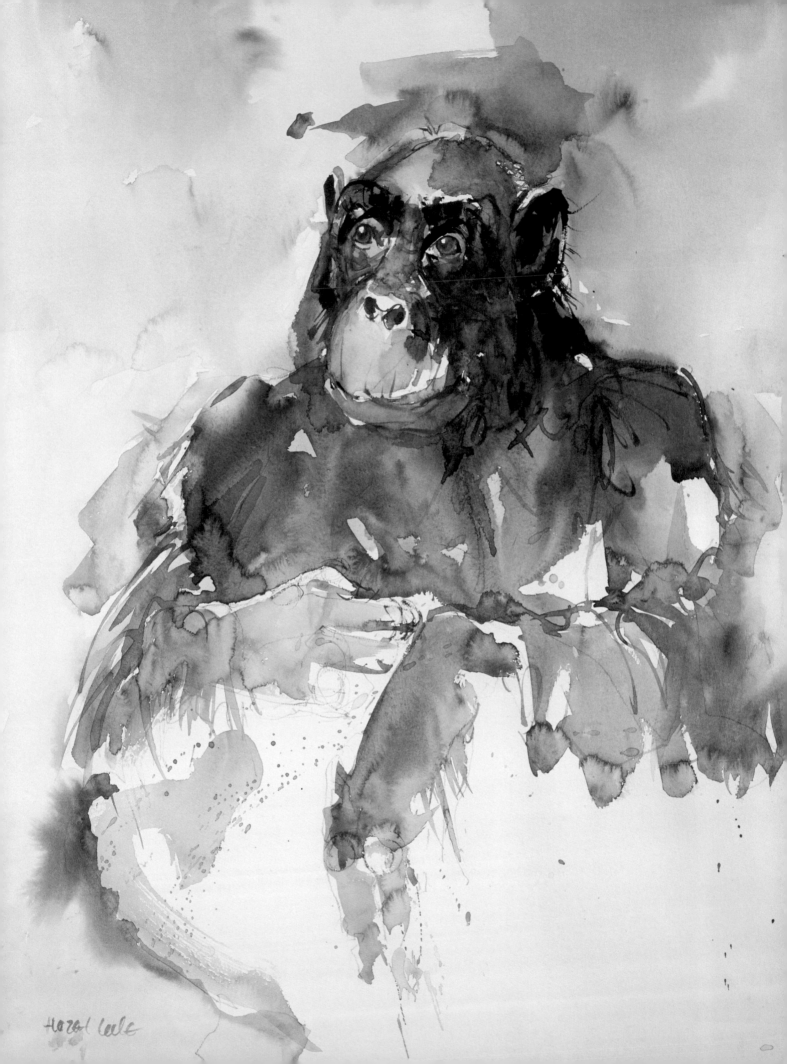

Hazel Soale

PERSPECTIVE, DISTANCE & CREATING SPACE

All marks on the flat plane of the paper surface are at the same distance from the viewer, and so we must create the impression of a deeper three-dimensional space through other means. This illusion is called perspective.

Through shape

At its simplest, we can use the placement of objects to suggest perspective. Shapes nearer to us appear larger and those further away diminish in size. Placing one object in front of another is usually enough to suggest a deeper space. If the second shape is reduced in size, the illusion of distance is complete.

Through colour

The detail of objects blur slightly as they recede from the viewer, losing detail and tone in a process called aerial perspective, or atmospheric perspective. This is caused by dust particles and moisture in the atmosphere which create a slightly blue haze in the distance. Knowing this, we can use blue hues to suggest that objects are more distant from us and warm red tones to suggest that they are close.

Form created by colour

Where a light source hits the surface of an object, the tonal value will be lightest. As the light progresses round the shape, the surface receives increasingly less light and drops in tone. Eventually the surface becomes dark in tone, with the darkest point away from the light source.

In this example, the circle appears to have a three-dimensional form. Yellow is the lightest-toned colour on my palette, so I have used it to indicate the direction of the light source (i.e. the top left). The cool blue shadow indicates the surface furthest from the light source.

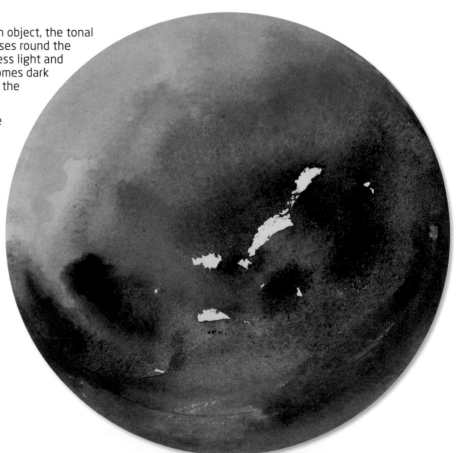

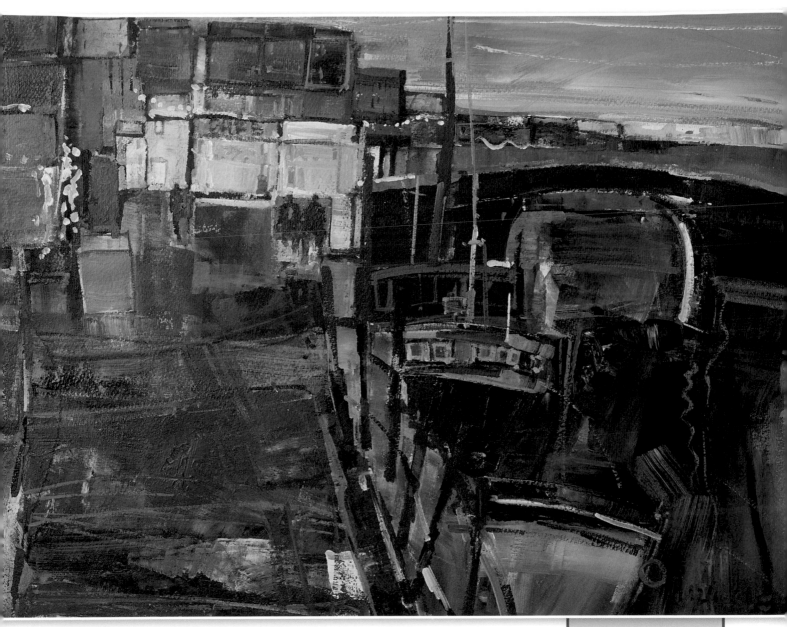

Distance and detail

In all paintings, there is a balance to be struck between freedom of paint marks and control. Do not be tempted to say too much with your painting – leave some areas less elaborate and they will fade into the distance, giving a more balanced and pleasing result.

This painting shows two figures walking along the harbour front in the early evening light, which exaggerates the shadows and makes distant details increasingly hard to see. There is a sense of distance here that is created both by linear perspective and aerial perspective. Note how the posts of the fence that are closer to us are larger than those further away, and the distant figures are smaller still. Along with the diminishing sizes of the shapes, the colours used help create a sense of increasing distance: the foreground path is warm red, while the distant buildings are cool blue.

The tone of the sky reinforces this effect. Compare the light muted blue of the sky with the stronger, darker blue of the water at the lower right. The contrast is strong, with the less detailed, pastel blue sky being less eye-catching than the sea.

Whitby Red and Blue

Although this is a mixed media piece, the principles of using warm and cool colours to create the impression of distance apply equally to pure watercolour work.

Balancing your paintings

A busy painting, filled with colour, multiple shapes and other structures keeps the viewer's eye dancing around the scene, while a simple composition can feel empty. Finding the balance between the two – having enough happening to interest the viewer, while leaving them some simple spaces where their eyes can rest – is important to a successful composition.

As a painter, the restraint necessary to leave open areas and white space can be difficult to achieve as you fight a subconscious need to keep going until the painting surface is completely filled. Remember that the idea behind a painting is more important than the subject – you do not need to fill every space.

In a painting like that shown here, I have tried to give very little and suggest a lot. This was achieved by using a tight palette and careful balancing of how I arranged the shapes and placed the colour.

On the face of things, *Evening Moorings* is a relatively simple composition – although, as mentioned above, it is often the simplest things that are the hardest to achieve. The sea could have been left a large blank area and the buildings filled with detail, but that would have unbalanced the painting by drawing the eye to the buildings. Instead, the foreground contains a variety of highly contrasting colours and strong marks to draw the eye, while the background buildings are rendered with a muted blue that is similar in tone to the sky.

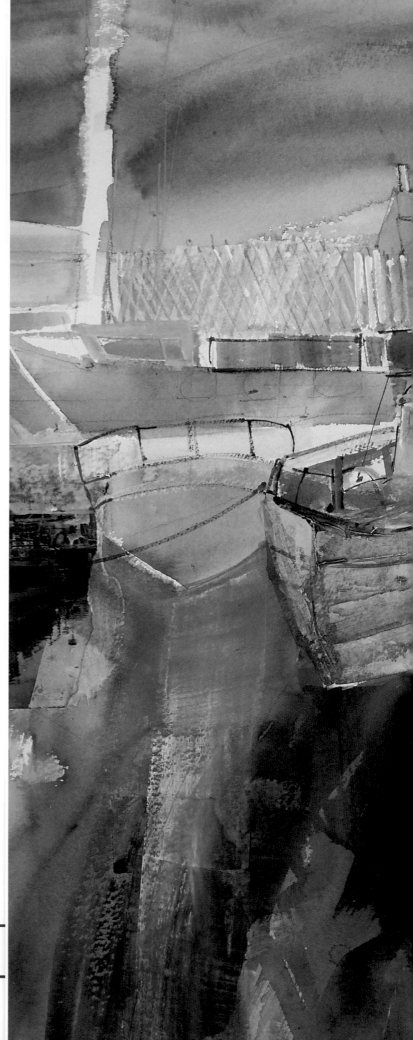

Evening Moorings

66

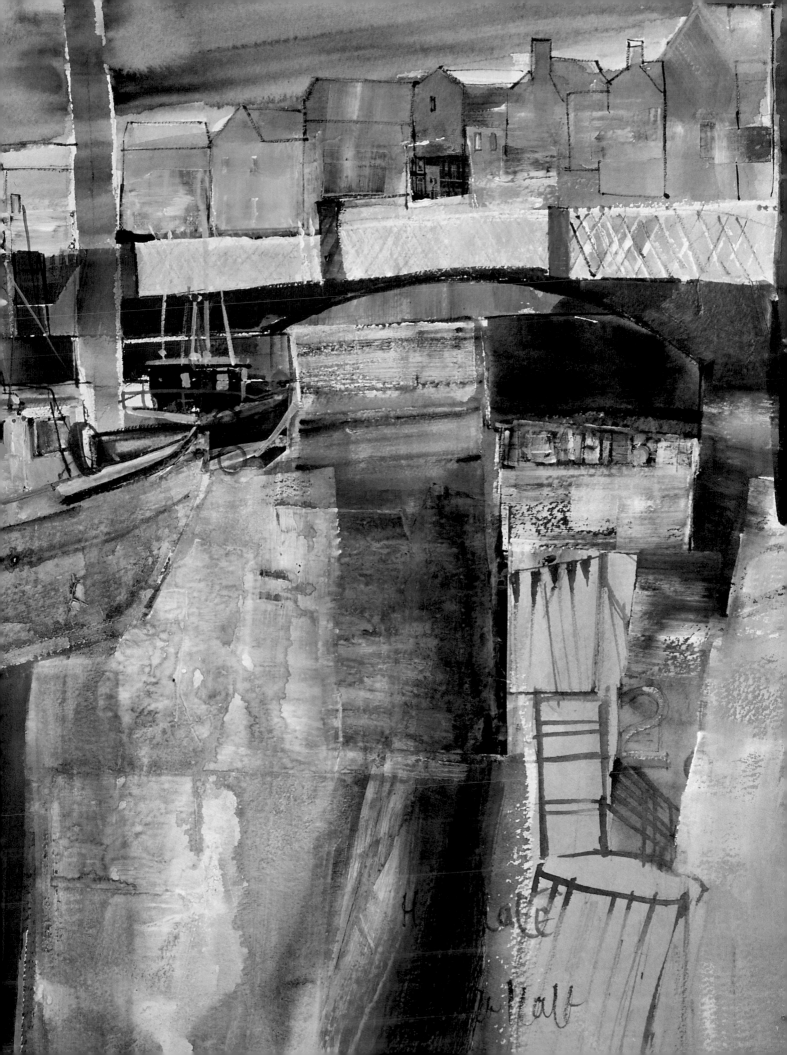

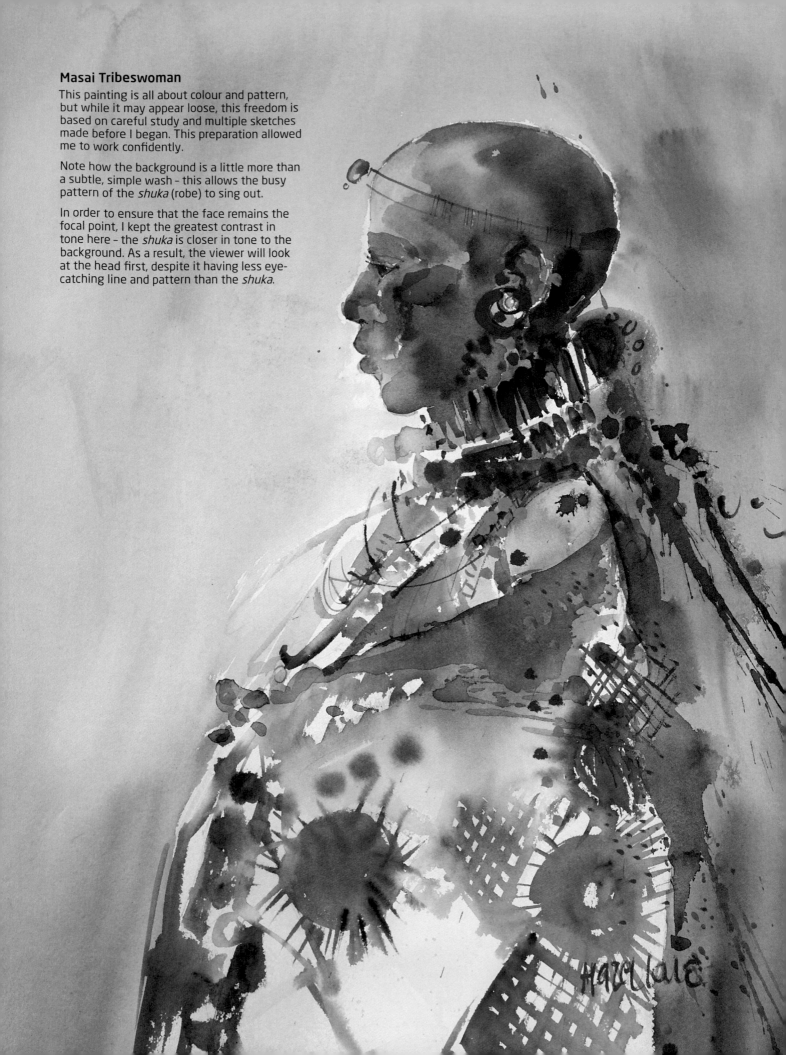

Masai Tribeswoman

This painting is all about colour and pattern, but while it may appear loose, this freedom is based on careful study and multiple sketches made before I began. This preparation allowed me to work confidently.

Note how the background is a little more than a subtle, simple wash – this allows the busy pattern of the *shuka* (robe) to sing out.

In order to ensure that the face remains the focal point, I kept the greatest contrast in tone here – the *shuka* is closer in tone to the background. As a result, the viewer will look at the head first, despite it having less eye-catching line and pattern than the *shuka*.

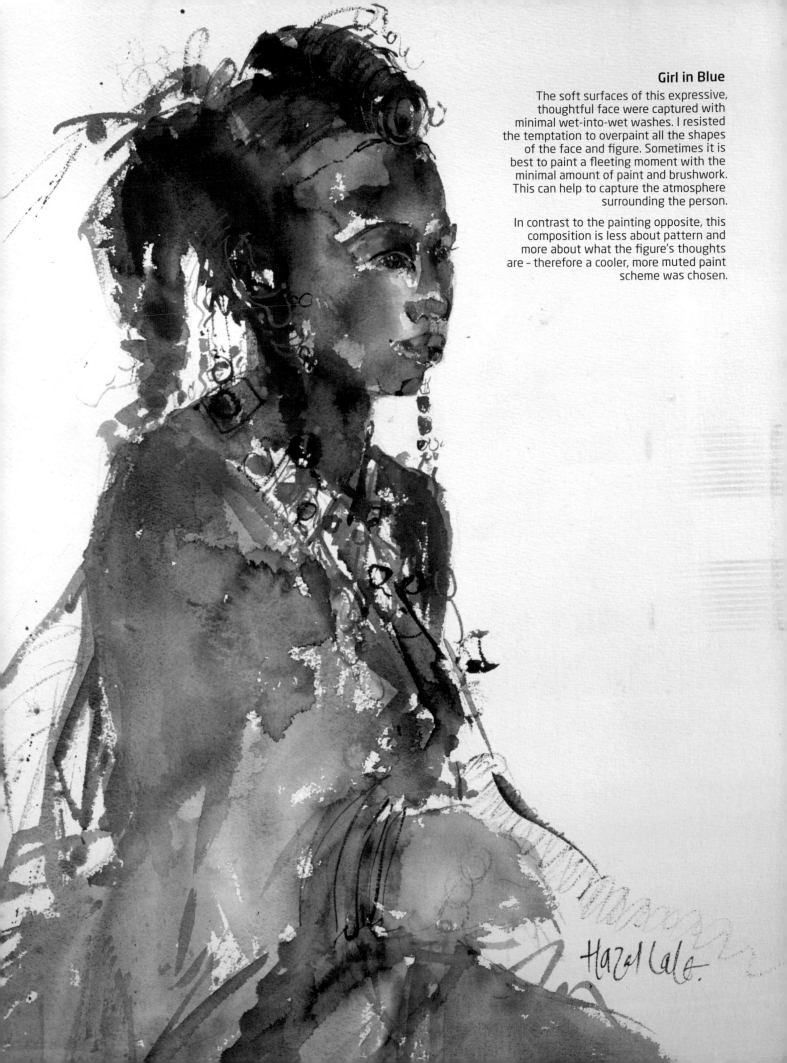

Girl in Blue

The soft surfaces of this expressive, thoughtful face were captured with minimal wet-into-wet washes. I resisted the temptation to overpaint all the shapes of the face and figure. Sometimes it is best to paint a fleeting moment with the minimal amount of paint and brushwork. This can help to capture the atmosphere surrounding the person.

In contrast to the painting opposite, this composition is less about pattern and more about what the figure's thoughts are – therefore a cooler, more muted paint scheme was chosen.

AFRICAN HEAD

The human figure has always been a subject of fascination for me. It is complex, varied and individual, while remaining fundamentally the same from person to person in its underlying structure. This demonstration will show you how to paint a head and shoulders portrait, building up from the basic forms of the features.

Fascinating and absorbing, drawing and painting the human form will improve your observational skills, which will in turn improve your drawing for any other subject you may wish to paint.

You will need

- Watercolour paper, 640gsm (300lb) rough surface, 56 x 76cm (22 x 30in)
- Watercolour paints: Winsor lemon, Winsor orange, scarlet lake, brown madder, Winsor blue (red shade), cobalt turquoise light, Winsor violet, Bengal rose
- Brushes: size 16 round
- 4B pencil and eraser
- Sketchbook

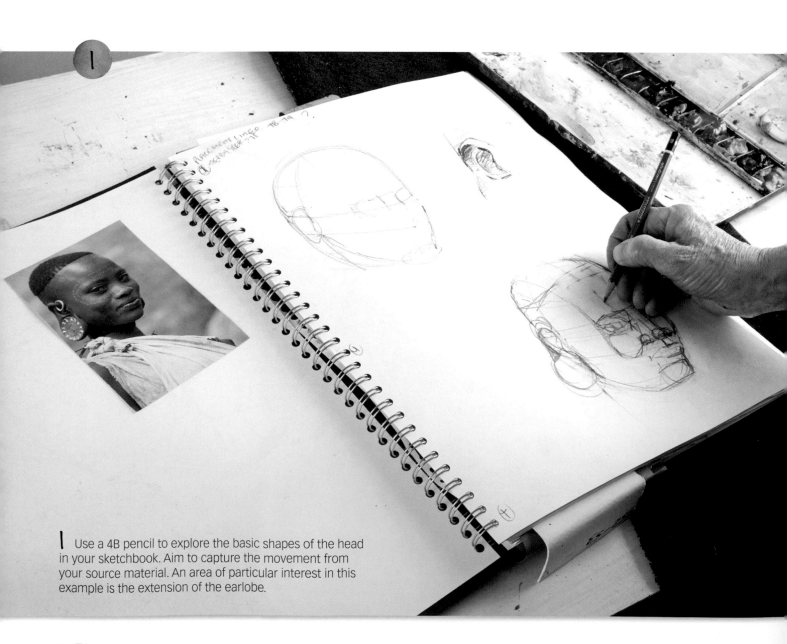

1 Use a 4B pencil to explore the basic shapes of the head in your sketchbook. Aim to capture the movement from your source material. An area of particular interest in this example is the extension of the earlobe.

Mouth

Ear

Eye

2 Prepare some additional exploratory sketches of other important features. Aim for accuracy, because these underlying parts of the structure are vital to eventual success.

3 Use your 4B pencil to make a sketch of the facial planes, adding a grid across the face to ensure that you capture the movement correctly.

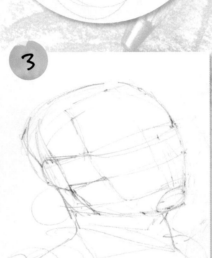

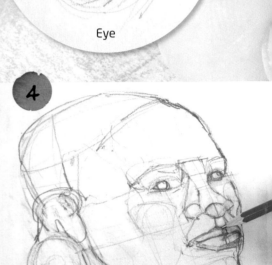

4 Add the features over the sketch of the facial plane, using the grid to ensure accuracy.

5 Prepare a tonal sketch using your earlier preliminary sketches as reference.

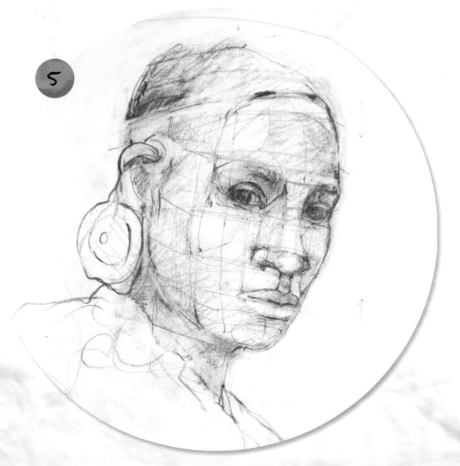

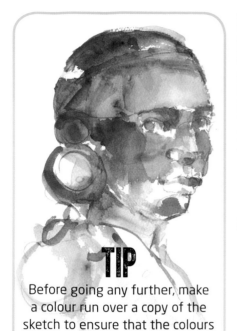

TIP

Before going any further, make a colour run over a copy of the sketch to ensure that the colours interact well. Look for vibrancy and the ability of the colours to create contrast and interest.

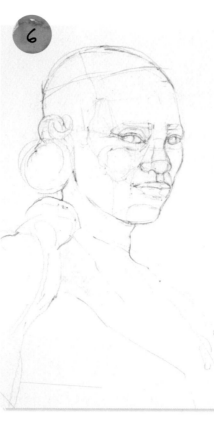

6 Prepare a final sketch for the painting using the 4B. Do not include any tone and use an eraser to soften the markings of the grid before you begin to paint.

7 Use the size 16 round brush to apply Winsor lemon over the whole figure. Use small strokes, leaving space to give you control. Apply the paint with the side of the brush.

8 While the paint remains wet, add Winsor orange to the areas of shadow. The clean dry paper between the areas will help you to control where the paint flows.

9 Add Winsor violet to extend the wet orange areas, spreading the colour and filling in the planes of the face and body.

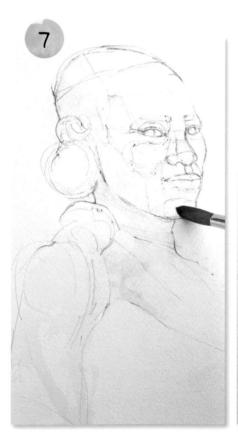

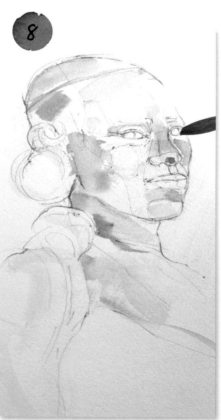

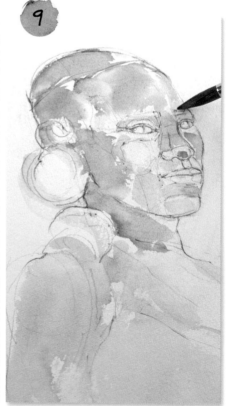

10 Begin to apply brown madder, which is the underlying skintone, to areas of midtones and shadow. The colour is dominant, so apply it sparingly.

11 Mix Winsor violet into the brown madder, then add Winsor blue (red shade). Use this blue-grey mix to develop the shadows by the jaw and in the orbital cavities.

12 Use touches of Winsor lemon to reintroduce light to the face where necessary. This vibrant colour will displace the colour underneath.

13 Holding the brush near the tip to give you control, touch very dilute Winsor lemon to the whites of the eyes.

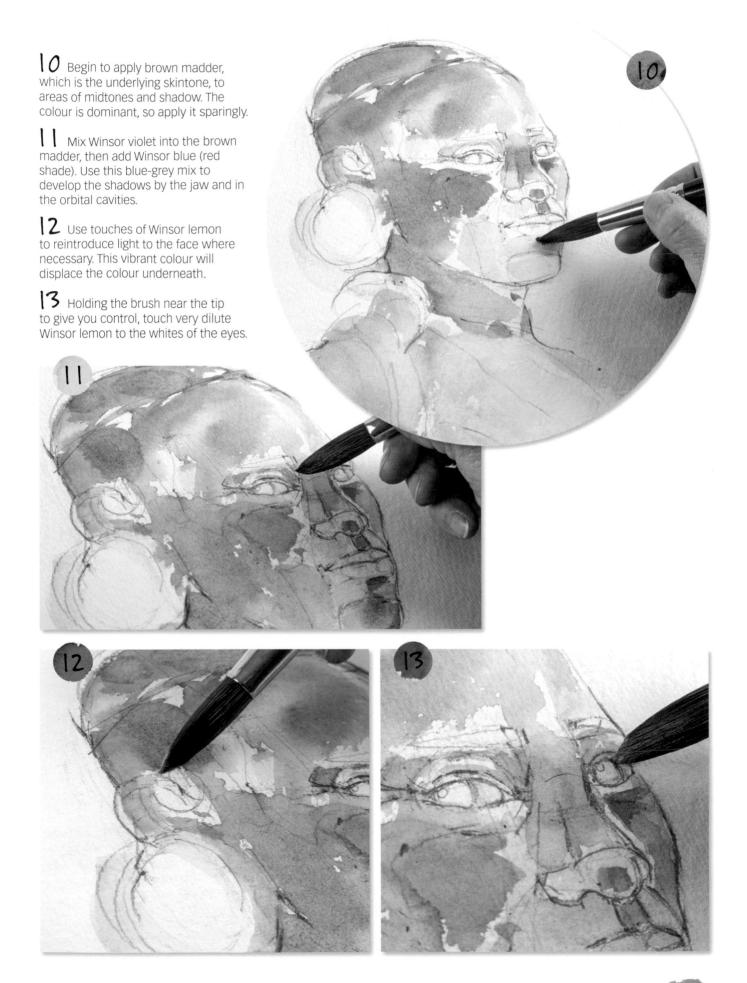

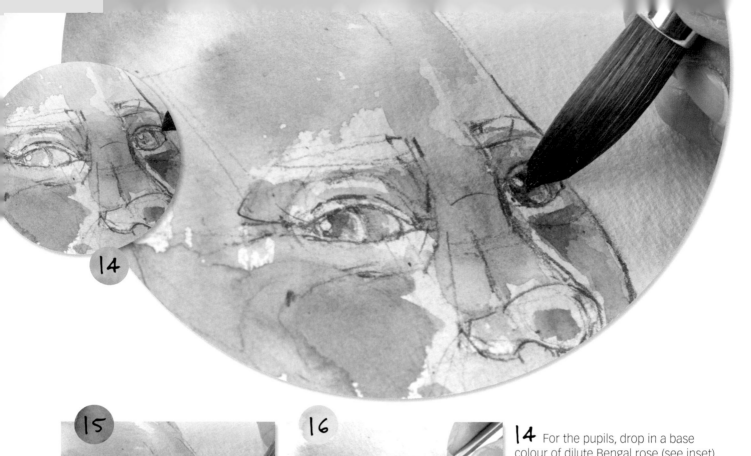

14 For the pupils, drop in a base colour of dilute Bengal rose (see inset), then add Winsor violet wet-in-wet.

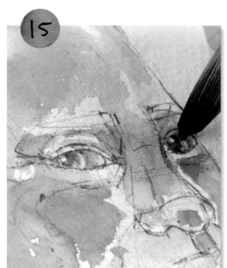

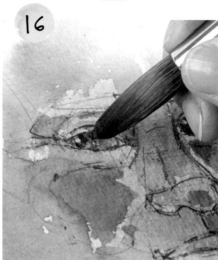

15 Build up the tone gradually, adding brown madder to the pupil and Winsor violet to the irises, before further strengthening the tone with Winsor blue (red shade).

16 Fill in the white spaces using the light value mixes on the palette. Use broader strokes across the body, letting the colour fade out. Apply dilute glazes of the colours to the existing areas of colour to strengthen them.

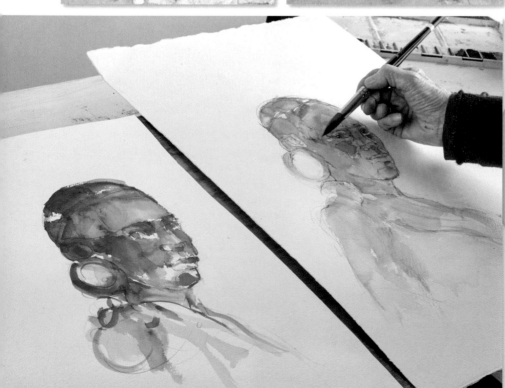

TIP

If you are unsure where to apply colour, refer to your colour run, which might provide a good prompt – or show you a colour combination to avoid.

17 Gradually introduce hints of warmth to the chin, cheeks and forehead using Winsor orange, then build up the shadows with the blue-grey mix of Winsor violet, brown madder and Winsor blue (red shade).

18 Introduce stronger colours in the form of Bengal rose on the lips and tips of the nose, plus stronger shadow colours on the darker areas of the face and body.

19 Highlight compositionally important features with warm touches of Bengal rose and Winsor lemon.

20 Build up and refine the face and body with these warm hues, then introduce cobalt turquoise light.

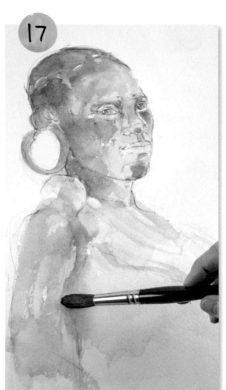

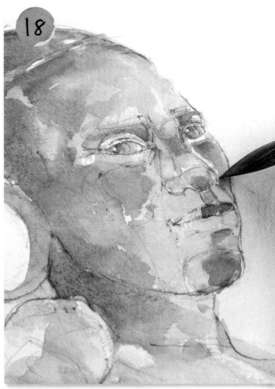

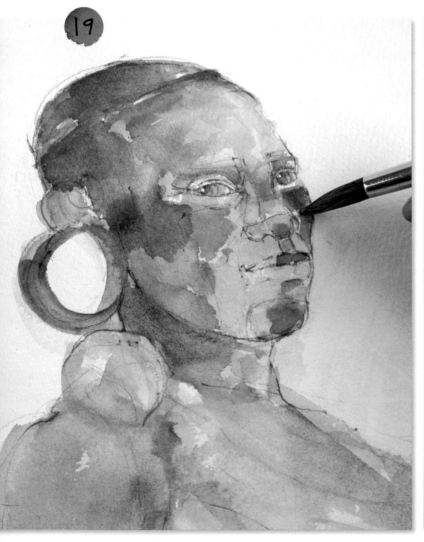

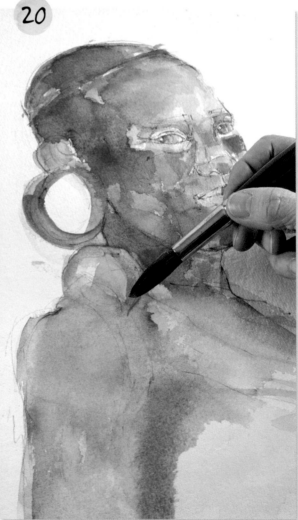

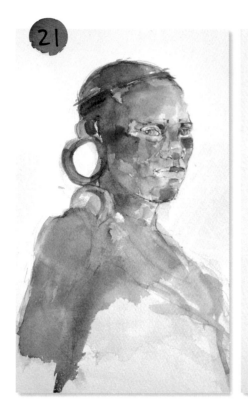

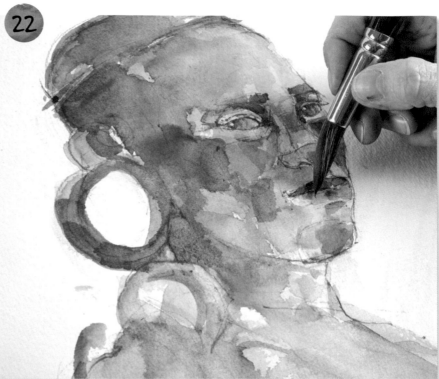

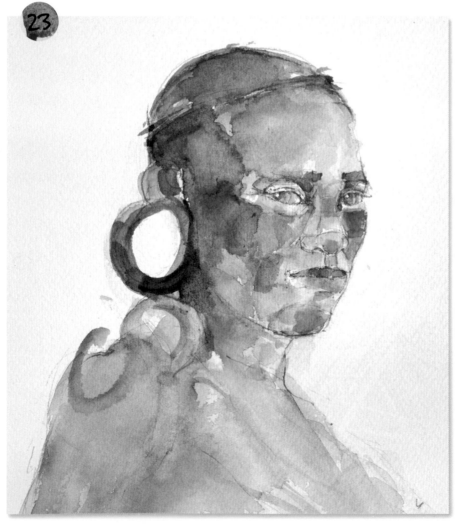

21 Mix Winsor blue (red shade) with Winsor violet and add small touches of this strong dark in recesses in order to throw areas forward. Develop these with hints of fairly strong pure Bengal rose and Winsor orange.

22 Use the point of the brush to delineate and develop the lips with a mix of Winsor violet and scarlet lake.

23 Refine the image using the mixes on the palette to finish.

Opposite:
The finished painting

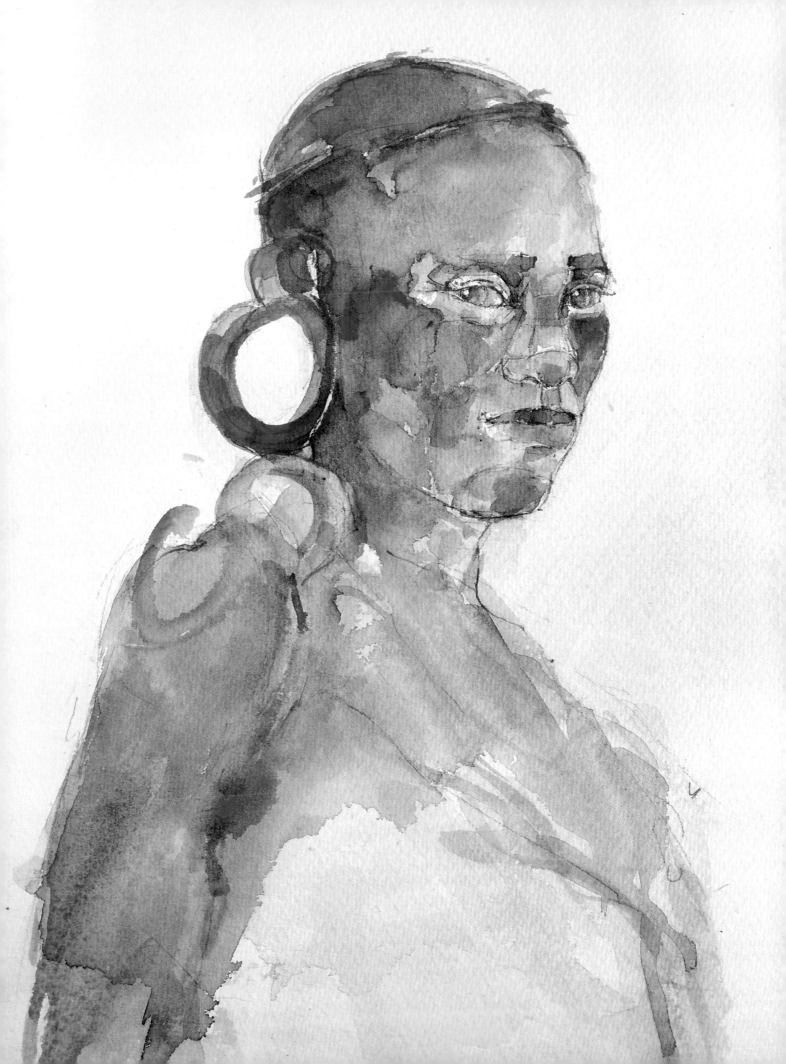

WALKING HOME

Street scenes, with figures walking or stopping to make conversation, are a subject always full of shapes, colour and movement. I usually rely on sketches and notes made on site, which allow me to capture the moment. Sketching from life is an enjoyable challenge. These quick drawings are not studies of every detail, but rather a way of finding the correct lines that describe spaces and tonal value.

Even if you work from a photograph, as here, try to remember the experience of being in the street. It will help to add spontaneity and energy to your brushstrokes and colour choices.

This demonstration will help you to practise creating depth and distance in your painting, without sacrificing vibrancy.

You will need

- Watercolour paper, 640gsm (300lb) rough surface, 56 x 76cm (22 x 30in)
- Watercolour paints: Winsor lemon, Winsor orange, Bengal rose, cobalt turquoise light, Winsor blue (red shade), Winsor violet, brown madder, scarlet lake
- Brushes: 50mm (2in) synthetic flat, size 16 round, size 10 round
- 4B pencil, eraser
- Permanent fineliner pen
- Sketchbooks

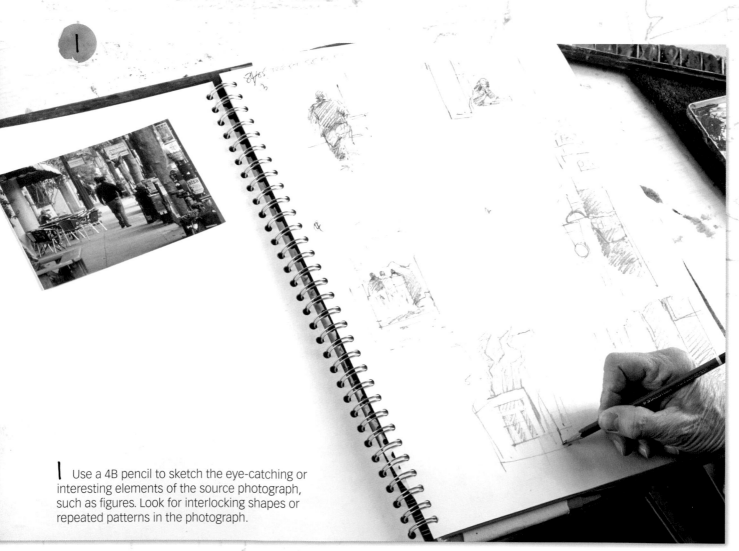

1 Use a 4B pencil to sketch the eye-catching or interesting elements of the source photograph, such as figures. Look for interlocking shapes or repeated patterns in the photograph.

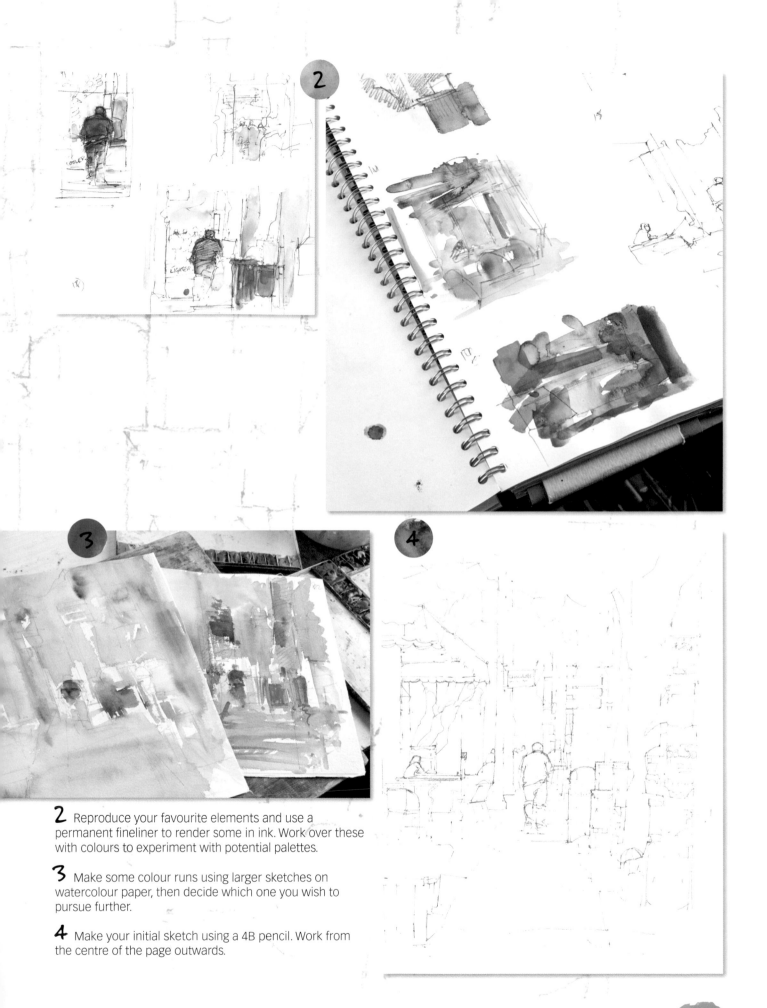

2 Reproduce your favourite elements and use a permanent fineliner to render some in ink. Work over these with colours to experiment with potential palettes.

3 Make some colour runs using larger sketches on watercolour paper, then decide which one you wish to pursue further.

4 Make your initial sketch using a 4B pencil. Work from the centre of the page outwards.

5 Wet the 50mm (2in) flat brush and pick up dilute Winsor lemon. Use broad strokes with the flat of the brush to apply areas of light across the painting. Use the blade of the brush for finer lines (see inset) and vary the pressure of the strokes.

6 Apply areas of Bengal rose over the painting in the same way, bringing some definition to the important shapes. Strengthen the colours by using less dilute paint. This will draw the eye to these areas, establishing movement and dynamism in the painting.

7 Still using the 50mm (2in) flat brush, add accents of Winsor orange.

8 While the paint remains wet, touch in cobalt turquoise in the foliage areas. It will mix to create interesting greens.

9 Add a strong cobalt turquoise light area to establish a tonal reference point for the other shapes. Use the underlying sketch to guide you, but not slavishly – feel free to work over and around the lines. Add Winsor lemon wet-in-wet to add variety in the areas.

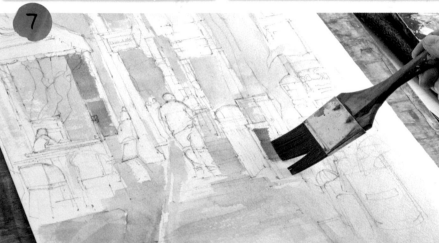

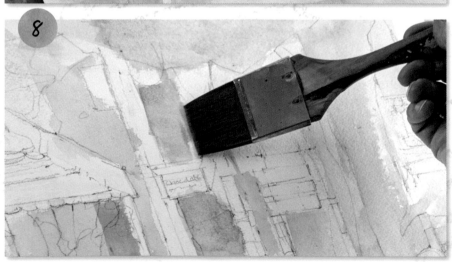

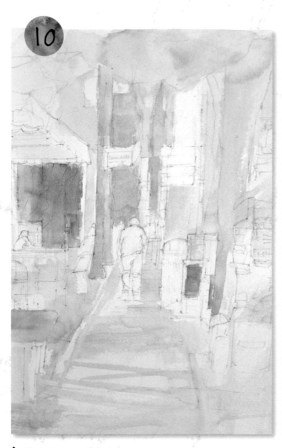

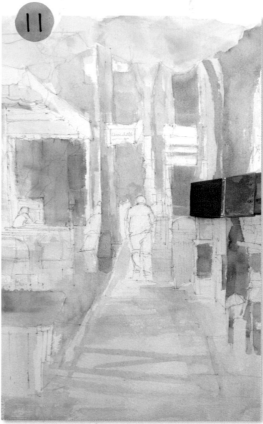

10 Build up areas across the painting with overlaying layers to give interesting, neutral darks. These can dry while you work on the more important focal areas.

11 Bring in some mid-to-dark tones in the lower right-hand corner and on the large trees, applying dilute brown madder with the 50mm (2in) flat brush. Vary the hue with Winsor violet.

12 Work as far as you are comfortable with the 50mm (2in) brush and the mixes on the palette, laying down the main colours, then change to the size 16 round brush and pick over the central figure with Winsor lemon.

13 Pick up Bengal rose on the tip of the size 16 round brush and drop it in wet-in-wet on the shirt. Introduce Winsor blue (red shade) on the trousers and hair.

14 Add Winsor blue (red shade) to the t-shirt area, letting us bleed into the Bengal rose. Strengthen the tones to make the figure a central anchor to the painting. Be careful not to make the colours too dark in tone, or you risk the figure falling out of balance with the rest of the painting.

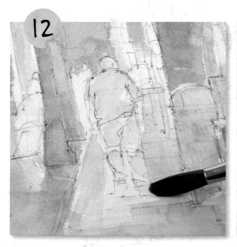

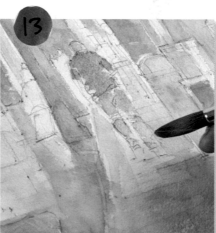

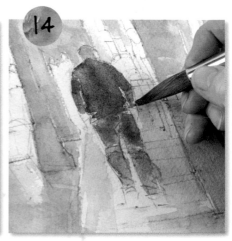

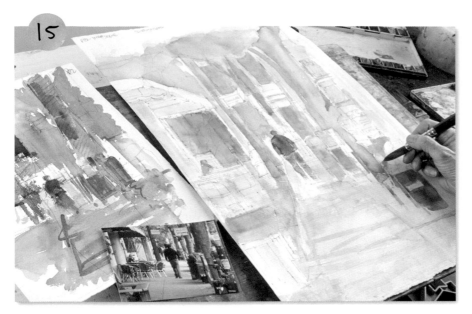

15 Knock back the remaining small white spaces using the size 16 round brush and midtones of the mixes on your palette. Refer to the colour run and original photograph as you work in order to direct you to the colours you need.

16 Establish some dark areas using glazes of a Winsor blue (red shade) and Winsor violet mix. Swap between the 50mm (2in) flat and size 16 round brush for different areas.

17 Add Bengal rose to warm the mix and glaze the foreground street, blending into Winsor blue (red shade) near the bottom of the paper.

18 Strengthen dark areas with the shadow mix and reintroduce touches of Winsor lemon and Bengal rose for bright areas.

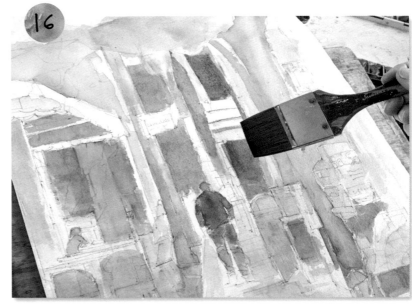

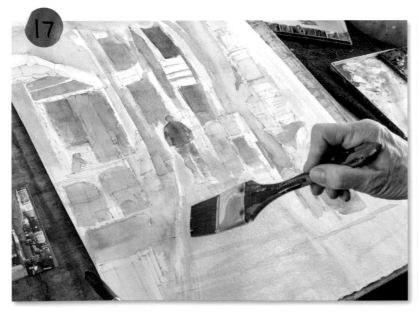

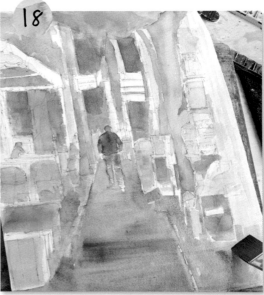

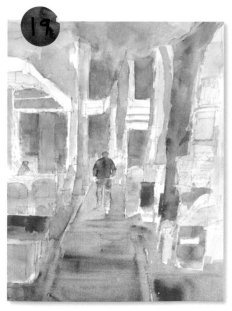

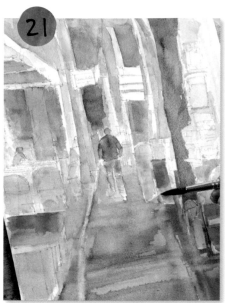

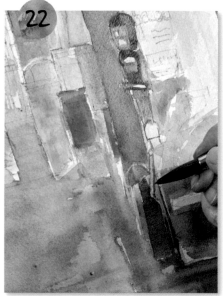

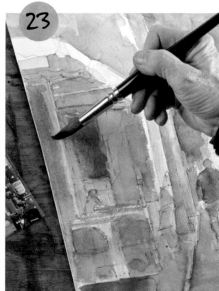

19 Warm areas using Winsor orange and add more brown madder to strengthen the tree.

20 Use quick, short strokes of the 50mm (2in) flat to add foliage with cobalt turquoise light.

21 Switch to the size 16 round brush and continue to build up the tone across the painting using increasingly strong glazes of the colours on your palette.

22 Block in the white posters using very dilute paint, applying it with the size 16 round brush, then use a dark mix of scarlet lake and cobalt turquoise light to introduce more detail in the foreground on the lower right-hand side.

23 Develop the shapes on the left-hand side of the painting with cooler hues – glazes of cobalt turquoise and cobalt turquoise light.

24 Strengthen the distant area with Winsor blue (red shade) and Bengal rose.

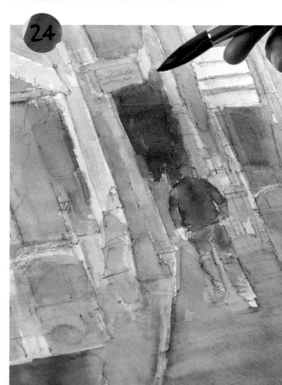

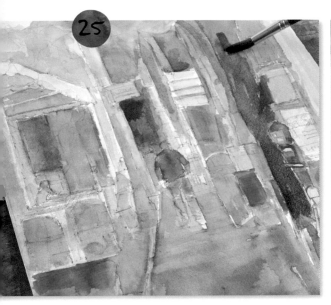

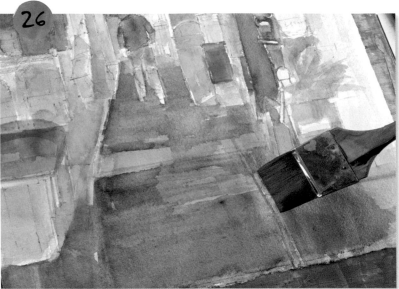

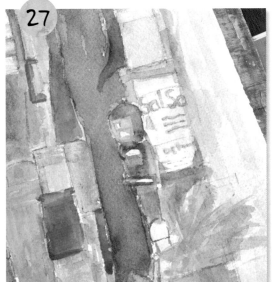

25 Continue refining the shapes across the painting to overlay the elements with stronger versions of the same paints and mixes as are already on the surface.

26 Add shadows across the foreground paving with dilute glazes of a Winsor blue (red shade) and Winsor violet mix.

27 Change to a size 10 round brush to add the final detailing such as the lettering on the posters. Use the paint fairly strongly for the distance, but keep the signage muted in tone to avoid it becoming dominant.

28 Switch to the size 16 brush to add a rich dark mix of brown madder and Winsor blue (red shade) below the central figure to ground him.

29 To finish, allow the painting to dry completely, then use a permanent fineliner to pick out and redefine the shapes. This makes the patterns and the forms stand out further.

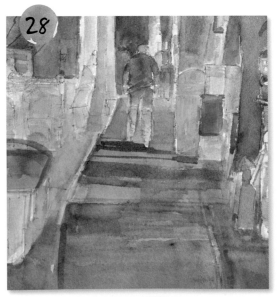

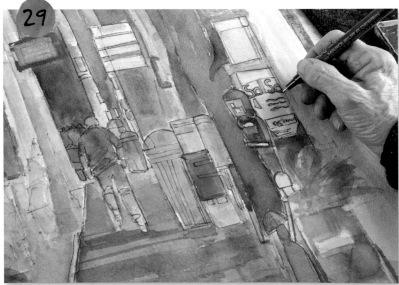

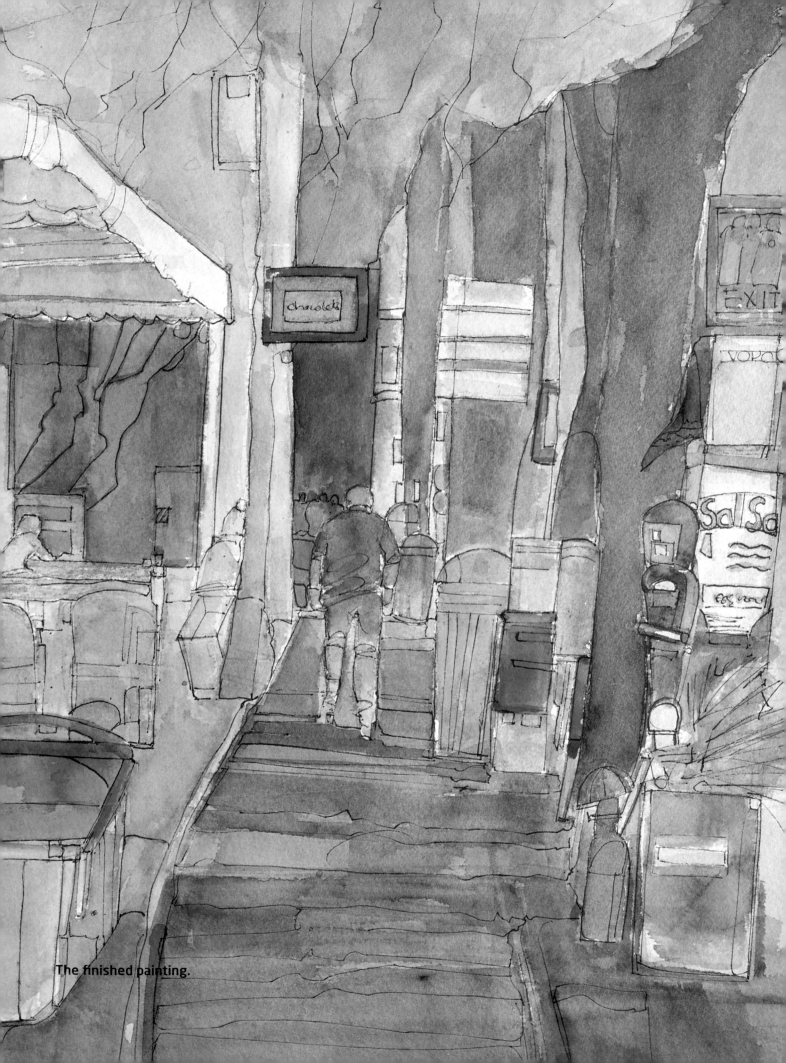

The finished painting.

PAINTING

FOR IMPACT

CREATING IMPACT

Using unexpected colours or techniques in how you treat the painting surface or subject will engage the viewer immediately. They might not be able to determine exactly what captured their gaze, but they will doubtless feel drawn into the artwork. This chapter explores different approaches to give your paintings immediate visual impact.

Going further

Successful paintings have a sense of coherency – they just 'feel right'. This usually stems from use of a limited colour palette or a repeat of similar shapes that create a pattern, as we have looked at earlier in the book. At some point, as you become more experienced, what you do with line and colour becomes intuitive. You can then try more unusual approaches with your paintings and take them further, with the aim of increasing the impact without losing that sense of coherency.

One way you might try this is to add multiple layers of glazes in order to create more extreme tonal changes. If you overdo a technique, or colour, you can knock back some of the painting's surface with a wash of diluted paint, called a glaze, added over the top. The example here, *Evening Light*, contains a considerable amount of detail and required many overlaid layers of watercolour washes in order to build up the strength of tone.

The challenge of this painting was to unify the whole. Disparate shapes on a large sheet of paper can be alarming when you begin to brush on layers of paint – it is easy to lose your concentration and make a mark that throws you off. However, I encourage you to remain ambitious. Even if a painting doesn't work the first time, you can always try again and build on what you have learned.

Evening Light
This is a subject I have explored in many different media before, but never in watercolours. I was prepared for it not to work, as the drawing contained a considerable amount of detail, but I persevered, using multiple layers of watercolour washes to build up strong tone. The result is pleasing, with strong contrasts in tone despite the complex palette, and the implications of empty chairs in different spaces is also a subject to which I intend to return.

89

Creating impact through colour and pattern

Market day is a familiar scene in most towns and cities. For artists, it is an opportunity to indulge in painting techniques that explore the colours and patterns formed by the awnings, stacks of boxes, piles of fruit and vegetables, and – of course – the people. These all add up to make markets wonderful opportunities for watercolour work. The addition of figures in particular helps to animate the scene: because they create their own patterns, figures help to create a sense of rhythm within the work.

The best advice I can give for tackling such busy scenes is to look for large main shapes and then repeat the patterns created by the stalls and their merchandise. This example is a close view of a stall in the foreground with a crowd of figures in the middle distance. This sort of composition offers the choice between creating a sense of space or keeping the focus of the whole painting on the shapes and colour.

When drawing a crowd, or figures at different distances, make sure that all the heads are at roughly the same height – the viewer's eye line – no matter where the figure is in the space. This can be used to create a convincing sense of distance.

I have approached this subject in many different ways, but this version is mainly about pattern and colour. Note the repetition of shapes in the foreground stalls: the circular oranges, curving bananas and gridded pineapples, along with the stacks of boxes, create a sense of eye-catching complexity even though the colours within each area were fairly simple to apply. Broken lines were overlaid on top of the colour washes to suggest the shapes of the fruit. Note how the colours used for this focal area extend across the remainder of the painting – but the viewer's eye is still drawn to the fruit because the background has less pattern and structure to draw the eye.

Fruit Stall

90

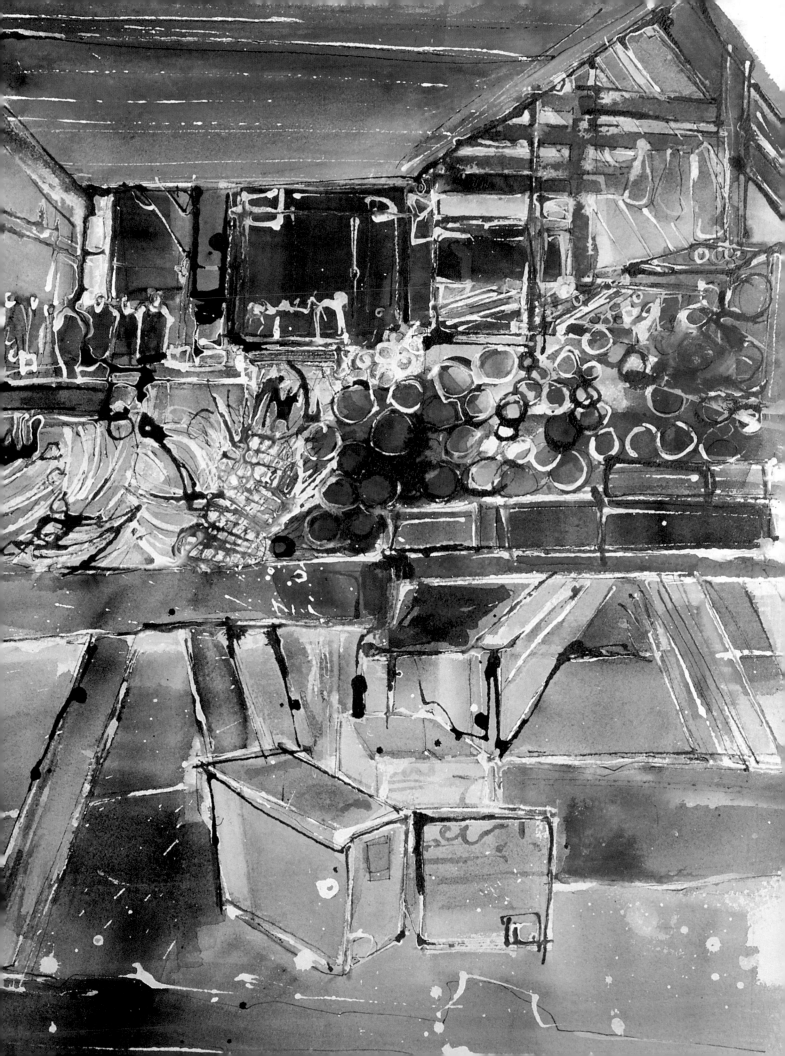

Creating impact through contrast

Still life paintings are typically calm and predictable, and so if you wish to create an artwork with more impact, you have to challenge this in some way; either through the approach you take or the techniques you use to paint the subject.

Start by exploring ideas in a sketchbook, trying to illustrate the familiar shapes in front of you in such a way that they invite the viewer to look a little more closely at the painting. Challenging accepted or obvious ways of working will add interest and draw the eye – even if the changes you make are very simple.

Most of us are most comfortable when an artwork conforms to what we consider an everyday reality, and so using devices that add visual contrast – such as introducing an arrangement of shapes that we know would cascade downwards in normal circumstances – is an aid to keep the viewer looking at the painting.

For example, in the painting opposite, I have stacked one apple on top of the other in a vertical line. This creates dynamism and tension through the sense that the apples may overbalance and topple. I have ensured that this does not unbalance the composition by placing the apples near the edge of the picture mount, and placing the bowl on the other side as a stabilising element. These elements frame and visually constrain the apples to give them a sense of stability without compromising the tension.

These elements of contrast are not limited to shapes and patterns. The colour choices we make can also help to create impact. The palette of colours used in *Still Life* contrasts the cool Winsor lemon and Winsor blue (green shade) with hot scarlet red and alizarin crimson. By their close placement together on the surface, the warm areas appear warmer and the cool areas cooler in contrast.

Opposite:
Still Life

This painting was made with very dilute washes: there was little pigment and plenty of water in each mix. The painting was an exercise in restraint for me: I usually plan to add to the layers and increase the intensity of the colours. Doing less with layers and instead concentrating on the drawing of the composition proved a worthwhile experiment.

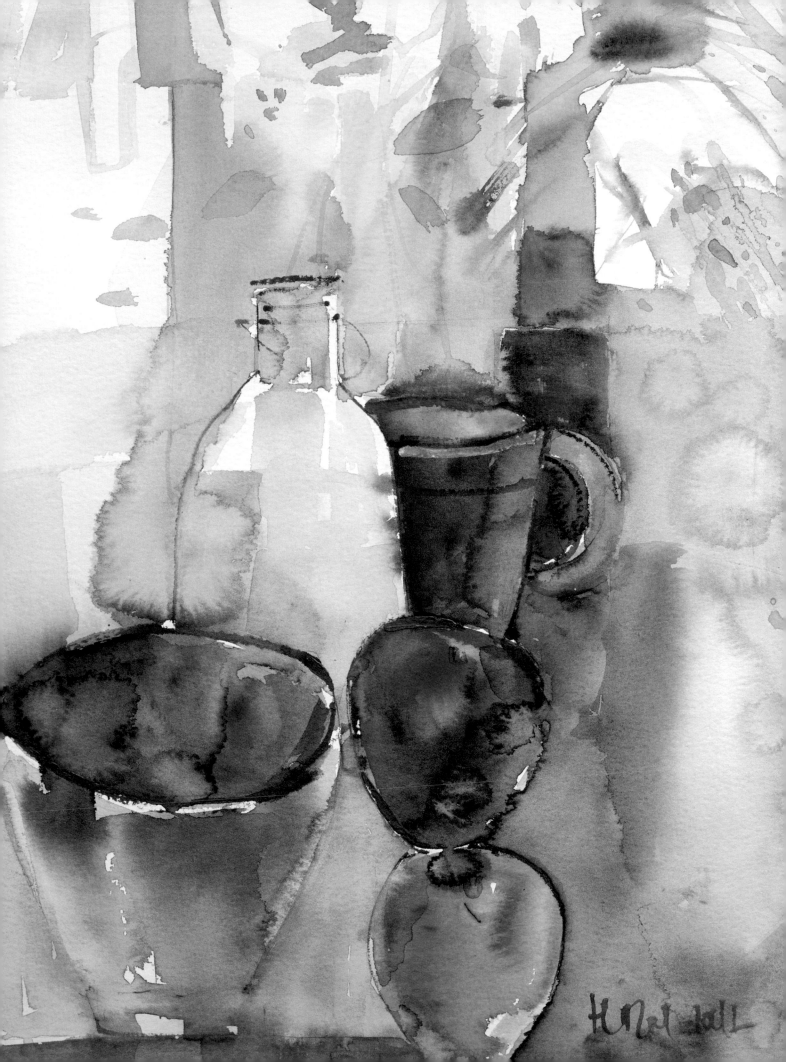

Creating impact through tonal colour

I spend a considerable amount of time just looking and thinking about the painting on the opposite page. It is a balance – if I spend too much time thinking, then that idea will likely never become a painting. Conversely, too little time spent looking at the subject will mean that it will never make it out of the sketchbook.

The Trombone Player is based on a street musician who immediately caught my attention while in New Orleans, USA. I made the sketch to the right on the spot, working quickly to capture what had drawn my attention. I wanted to capture the gaze, turn of the body and the hat he was wearing.

Wherever you might be, people are accessible subjects to draw. Because they are rarely still for long, it encourages you to draw with some speed. This is turn makes you consider which lines are essential to make the drawing believable. Capturing the moment in sketches helps to keep things simple. Your hand is forced to put in as few lines as possible – abbreviating the scene and concentrating on shapes and movement is an exercise in keeping things animated and fresh. The speed of drawing like this forces you to look carefully for the important basic elements and help to catch just the essence of what is going on around you.

In this example, the idea behind this work was to draw and paint a tonal study that was as minimal as possible – adding too many colours can distract from the focus, and tone can add impact and vibrancy just as effectively as hue.

I concentrated most of the detail and suggested form around the head, which was the focal point. The gaze, turn of the body and the hat he was wearing lead down to the shoulder line. This area, which has the strongest contrasts in tone, is visually suspended from the top of the paper's edge by a relatively strong background wash. Further from the focal point the wash is more dilute, reducing the tonal contrast and detail.

Away from the head, the detail becomes less clear, as I blended out the paint in terms of both line and tone. Much of the rest of the body is suggested only lightly by tapering lines and white spaces, but the slightly stronger diagonal lines of the trombone steer your gaze back towards the centre of the image.

The result uses fairly muted hues, but the use of tone ensures the painting retains a powerful impact, leading the eye from the more ethereal tones of the background and body to the strong contrasts in the hat and face.

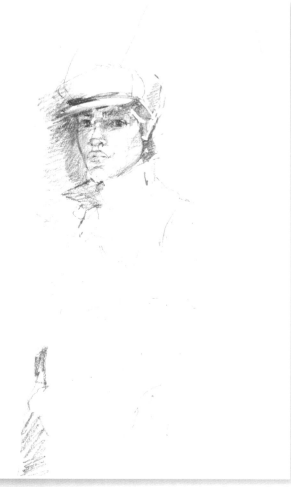

The initial sketch for this painting. I used the head as a unit of measurement when drawing the rest of the figure. The height of an adult's head is usually a seventh of their overall height when they stand upright, which provides a useful guideline when sketching quickly.

Opposite:
Trombone Player
Walking towards me was the enigmatic figure of the trombone player - then, a momentary glance in my direction. With the sun shining down on the square where I sat, I put my head down in concentration, drawing in my sketchbook to capture what was playing out in front of me with a few lines.

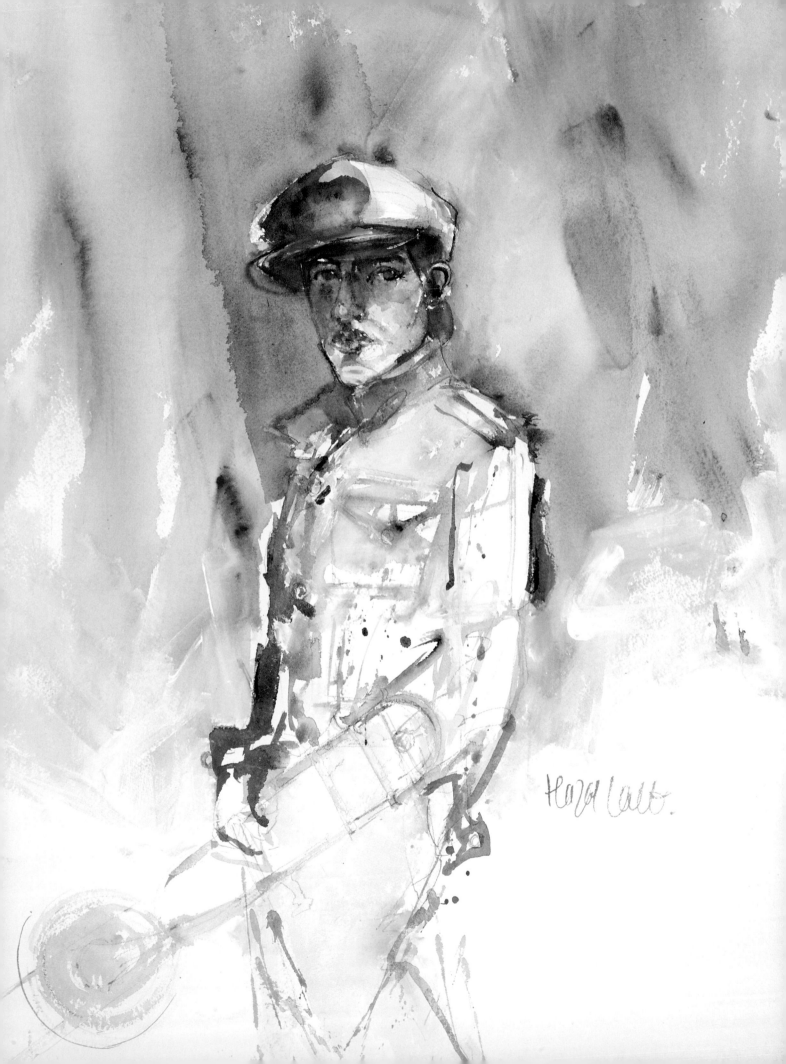

Mood and impact

One of my favourite things to do is meander around country villages, exploring cobbled streets and alleys tucked away between cottages. This particular scene came about during one of my many walks in the countryside.

The views of any scene can vary depending on the time of day and, of course, the weather. The late afternoon light on this occasion gave the scene an ephemeral feeling, which I wanted to capture in this painting. This is a little different for me, as I usually look for strong contrasts and bold colours – the challenge would be to sympathetically suggest the light without creating a bland finished result.

After some consideration, and much note-taking, I almost abandoned the painting altogether, but decided to keep going. My main concern was the foreground, which had a multitude of small shapes around one overall expansive shape. I made the decision to simplify the area, staying with the larger shapes and making the view of the buildings the focal point.

To begin the painting, I applied a light value wash of Winsor lemon across the whole surface, leaving gaps of dry paper to give control as I added other colours. I then brushed in rose madder along with a small amount of Winsor orange. These colours had very little water in the mix as the Winsor lemon wash on the surface remained wet, which provided all the water I needed. I left the paper clean and without paint around the buildings. This was to give me some control around these areas and to provide contrast with the wet washes that cover most of the paper surface. Once the paper was almost dry, I added extra, slightly thicker areas using the same colours – even the trees share the same colours as the background, with the only additional paint being a dash of opera rose.

This all results in a fundamentally monochromatic painting with slight shifts from light value pinks and yellows to darker mixes of brown and orange madder. The foreground and the trees were created with large brushstrokes – in fact the whole painting was made using just one large brush. The shape describing the village buildings is what carries the interest of the whole painting, and it is this feeling of looking through a keyhole that encouraged me to take the painting through to resolution.

We all have some form of emotional response to colour, and I have purposefully kept the palette small and warm, and used similar tonal values, to give that dreamy, late-in-the-day feeling.

Stoney Middleton

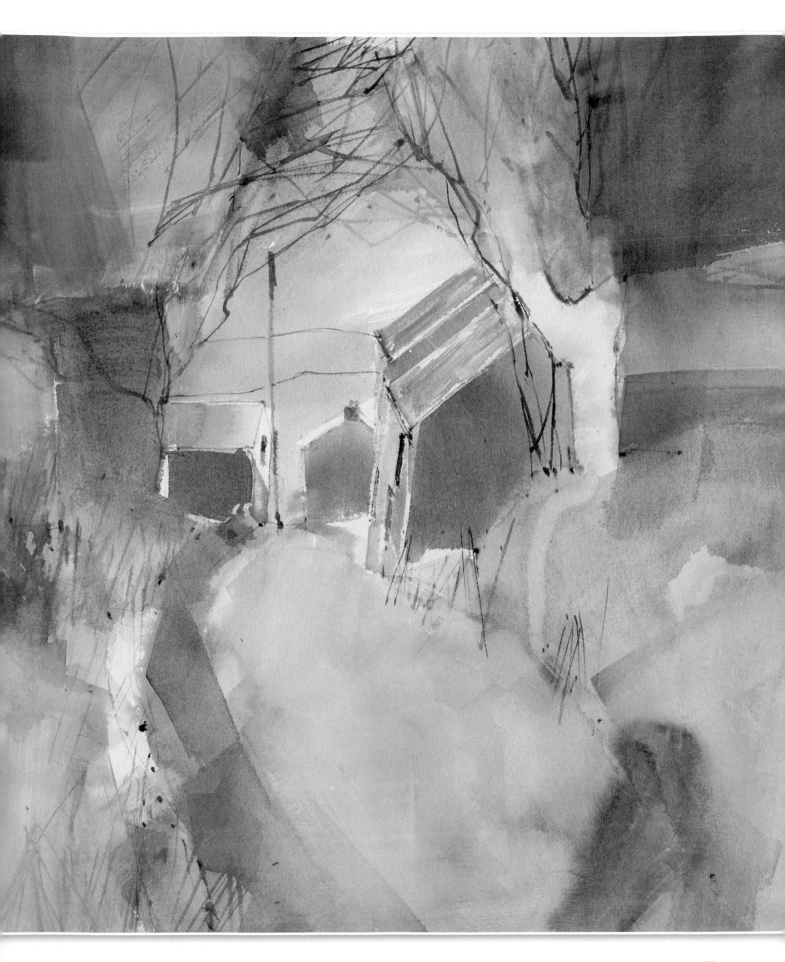

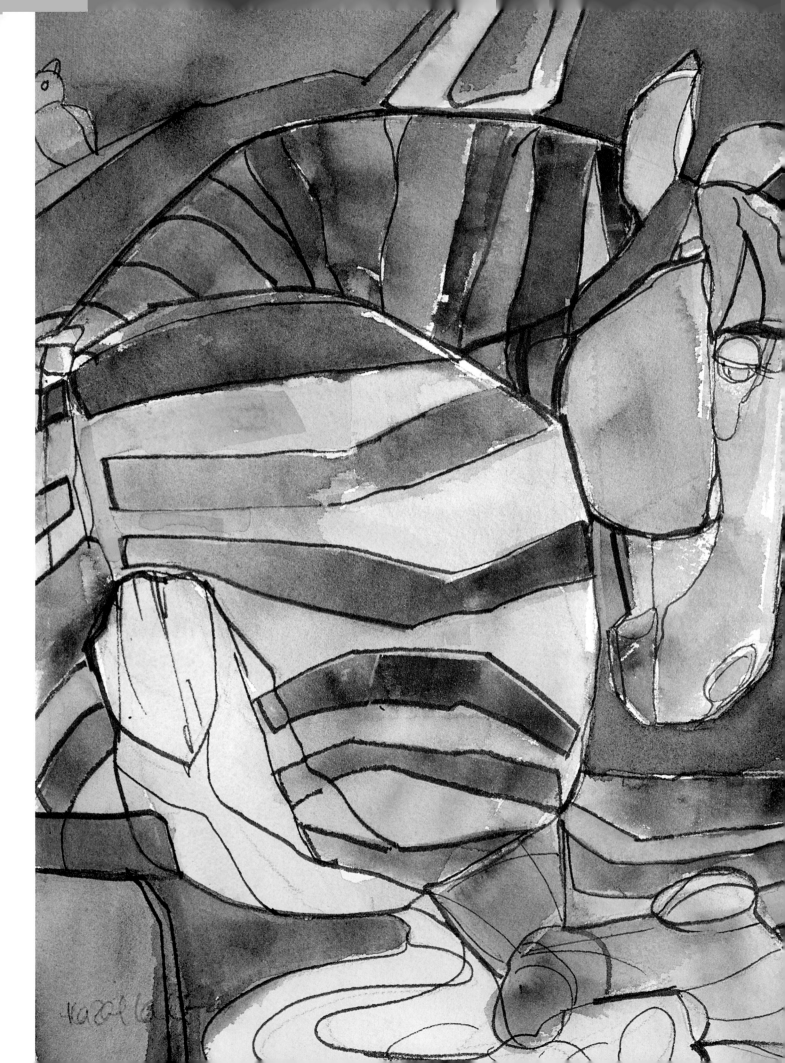

The final sketch.

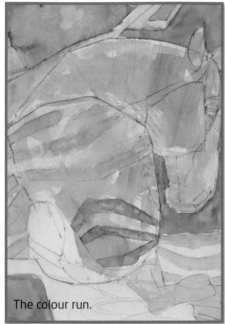

The colour run.

Opposite:
A Visit to the Zoo
Note the suggestion of a small bird resting on the zebra's back - a trip to Africa made me aware of how many animals and birds co-exist in a mutually beneficial relationship.

CONFOUNDING EXPECTATION

After many years of painting, the majority of my work arises from a mix of intuition and considered thought. At times, maintaining this is a difficult balance as I really enjoy pushing the boundaries of what I can achieve and exploring new ways of looking, a process that continually affects the way I approach painting. As long as you are attentive to the work and don't just plough through making your images in a repetitive, familiar way, you will continue to progress on your painting journey.

For this reason, it is essential that you continue to challenge yourself and the way you see, by deliberately attempting things in a way you never have. Eventually, you will find that your paintings will begin to tell you what they need, and your art will improve.

Making diverting and interesting artwork is just another way of bringing vibrancy into your watercolour work. This chapter looks at more unusual approaches you might like to try for your watercolour work. Don't regard them as the be-all and end-all, but merely as examples of how you can add interest for viewer – and yourself – with your art.

Unusual composition

We saw on page 92 that you can add interest to your artwork by moving away from comfortable received ideas. One way you can do this is to experiment with an unusual viewpoint, as in the example on these pages.

Animals are a subject to which I continually return. They suggest an almost infinite combination of shapes and movement, which keeps you looking and checking proportions and colours. It was the view from the back of this zebra that first caught my attention.

The resulting painting is a portrait format close-up from behind the zebra's shoulder. The unusual angle distorts the image, completely filling the central area of the painting with the top of the zebra's leg, and the head – usually the focal point – pressed in to the right-hand side. The resulting impression is of the zebra turning in the frame, moving away even as we capture it; which results in a much more distinctive and arresting image than a more traditional approach.

I love the rhythm and colour of the stripes in this subject. The animal is pattern, form, colour and movement; all in one small, contained space.

Placing the subject in an unusual way

We often have preconceived notions about how a painting or composition should look. We expect the subject of a portrait or figure painting to be near the centre of the picture frame, looking out at or slightly past us. Playing around with the composition and trying something new is a great way to add vibrancy and interest to your painting.

The strong pattern and bold contrasts in tone of zebras mean that you can paint them with no outline and they will still be immediately recognisable. This image, of two zebras leaping at one another, is made up of broken lines and loose touches, but it remains instantly recognisable.

This painting is a good example of a triangular composition. The overlaid lines on the detail below shows how the subjects form a triangular shape in the middle of the painting space, which gives the zebras a sense of movement and opposition to one another. Perhaps more importantly, it creates a sense of movement, rhythm and energy that would be entirely lacking from a more conventional image of the zebras from the side.

Opposite:
Zebras

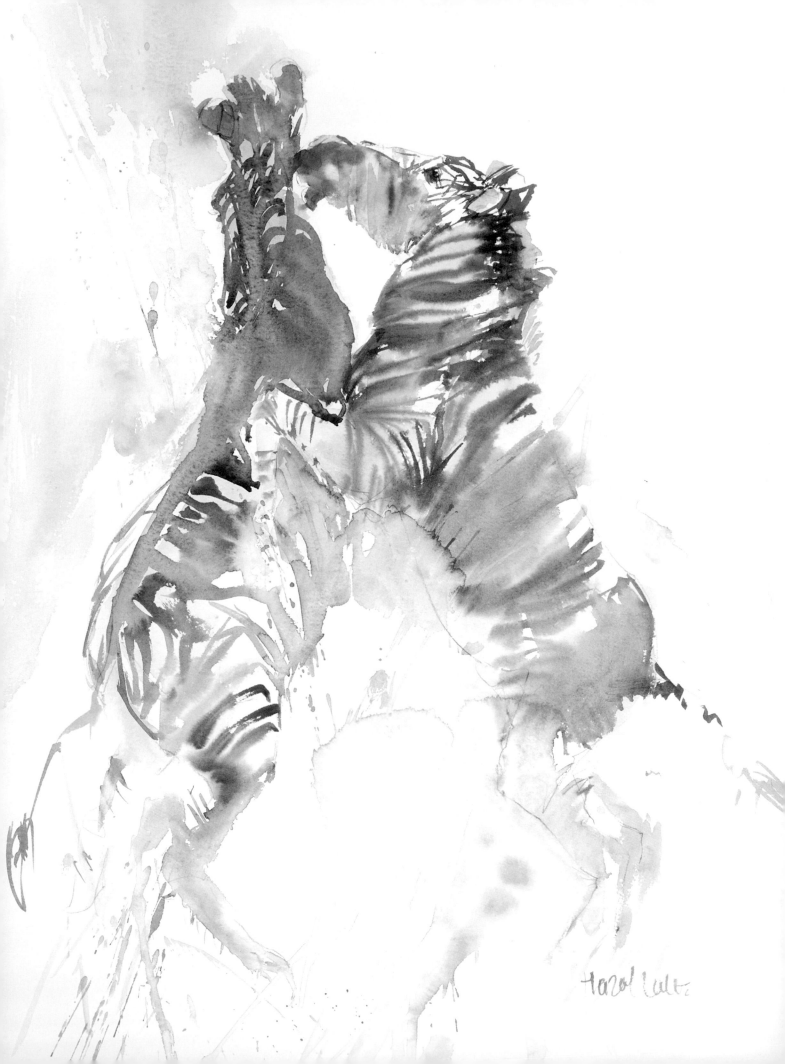

MOVING ON

Our modern lifestyles mean that we often pass people without any interaction; catching just momentary glimpses of figures. In these moments, the feeling of passing by and moving on can leave empty visual spaces. The idea of figures in space is one I have previously explored in one of my solo exhibitions in London.

In this example, I have intentionally placed the figure off-centre, looking out of the picture plane. The large space behind the figure feels disengaged and catches the eye. We become more aware of the void than the figure, and this causes a sense of disquiet as we unconsciously try to fill it in.

This type of composition is used frequently in film and televisions to convey a message of disquiet and solitude; and here it provokes the question of whether the figure or the space is the focus of the image – creating a sense of tension which is highlighted by the most eye-catching colours being reserved for the background rather than the subject, as we might expect.

You will need

- Watercolour paper, 640gsm (300lb) rough surface, 56 x 76cm (22 x 30in)
- Watercolour paints: Winsor lemon, Winsor red, Bengal rose, Winsor blue (red shade), brown madder, Winsor violet
- Brushes: 50mm (2in) synthetic flat, size 16 round
- 4B pencil and eraser
- Sketchbooks

I Use a 4B pencil to make sketches to experiment with different compositions, altering the tilt of the head, for example, or showing more or less of the torso. Here I wanted to avoid the subject looking directly out of the frame, so I altered the head to be slightly tilted, suggesting a pensive expression.

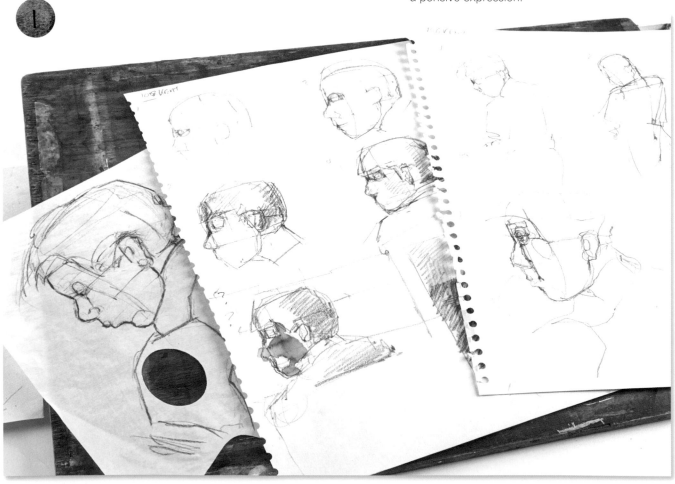

2 Make some colour runs to experiment with different colour palettes. Try some fuller figure sketches that show the body as well as the head.

3 Make a large sketch and produce a more developed colour run. Note how I have used stronger colours on the right-hand side to anchor the figure. This helps to make it clear the figure placement is intentional.

4 Referring to your preparatory materials, make a final sketch using the 4B pencil.

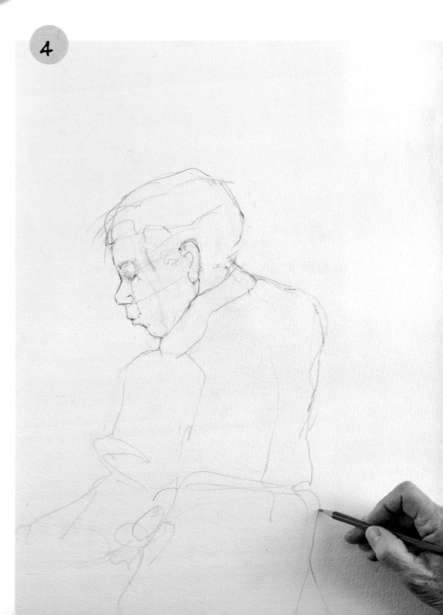

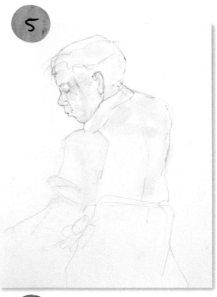

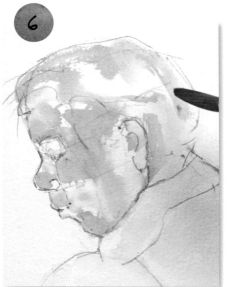

5 Apply Winsor lemon using the size 16 round brush to describe the form of the head and hair, then extend it down the body.

6 Add dilute brown madder to define the facial place and shadows.

7 Mix Bengal rose with a little brown madder. Apply that to the side of the face, nose, top lip and other warm areas on the face, hair and collar. Dilute the mix and use the 50mm (2in) flat brush to extend it over the body.

8 Use broad, flat strokes to block in the background, making the dilute mix of Bengal rose and brown madder still more watery in front of the figure.

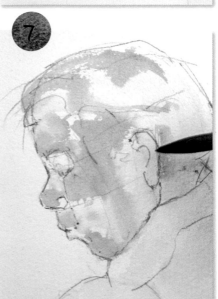

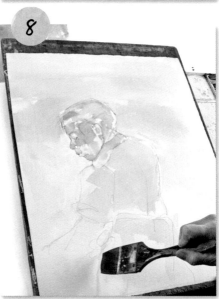

9 While the paint remains wet, make a deeper mix of Bengal rose, brown madder and Winsor blue (red shade). Use the size 16 round to strengthen the hair with light strokes of the brush, then add touches of pure Winsor lemon.

10 Strengthen the shadows on the face and hair with brown madder and reinforce the shirt with another layer of the dilute Bengal rose and brown madder mix.

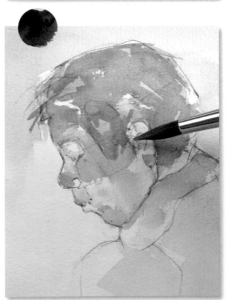

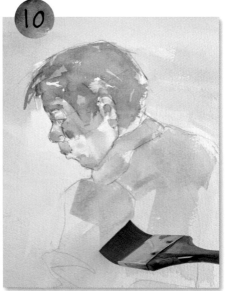

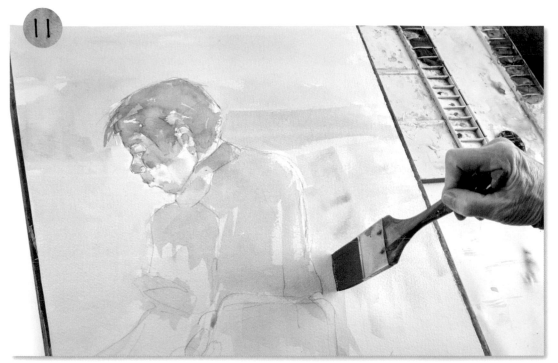

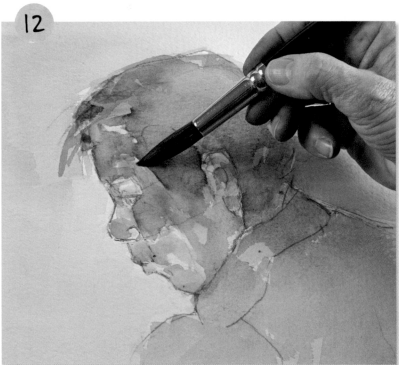

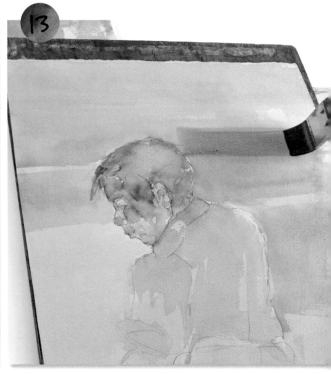

11 Build up the top and right-hand side of the background using the same brush and mix, but use Winsor lemon on the lower-left in front of the figure.

12 Change to the size 16 round brush and strengthen the hue in the face with touches of dilute Winsor blue (red shade) and Winsor violet, adding in the iris of the eye at the same time. Use Winsor lemon in some areas to avoid the face becoming too dark.

13 Reinforce the background with additional layers of the previous colours, switching back to the 50mm (2in) flat.

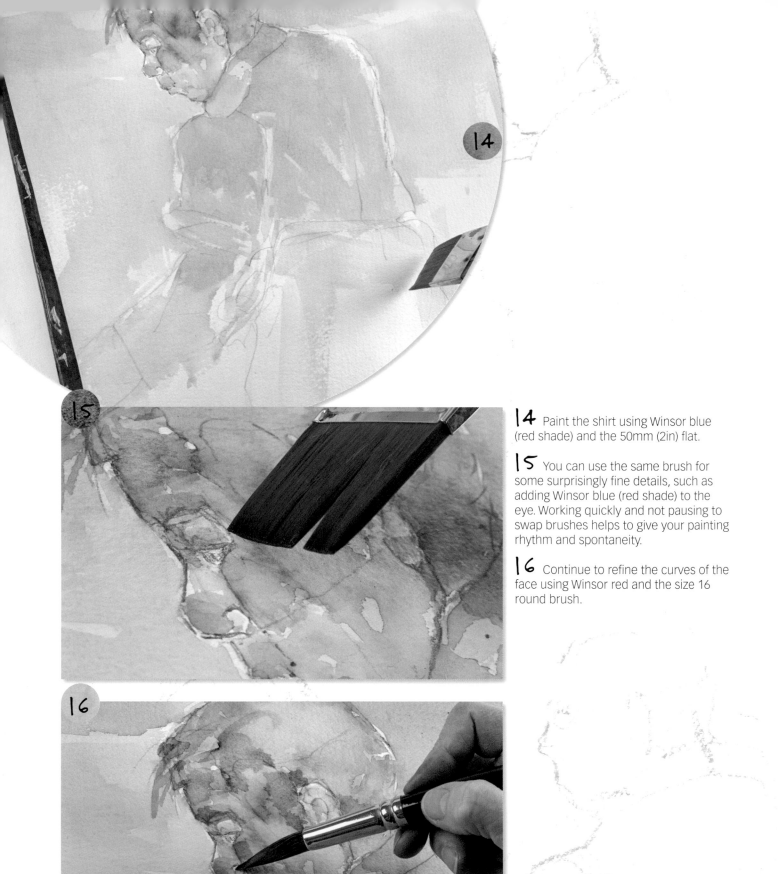

14 Paint the shirt using Winsor blue (red shade) and the 50mm (2in) flat.

15 You can use the same brush for some surprisingly fine details, such as adding Winsor blue (red shade) to the eye. Working quickly and not pausing to swap brushes helps to give your painting rhythm and spontaneity.

16 Continue to refine the curves of the face using Winsor red and the size 16 round brush.

17 Strengthen the tone in the hair with a mix of Winsor violet and brown madder.

18 Build up the background with the mixes on the palette, balancing the tone against that on the head.

19 Return to the face, adding warm touches of Bengal rose and Winsor red.

20 Strengthen the background further, adding horizontal strokes of Bengal rose and brown madder to overlay the earlier washes of colour.

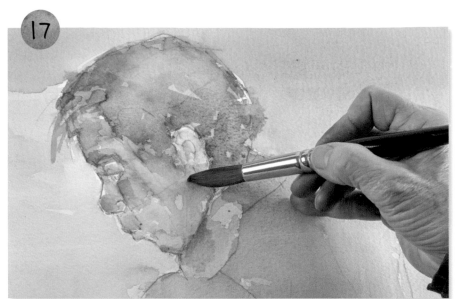

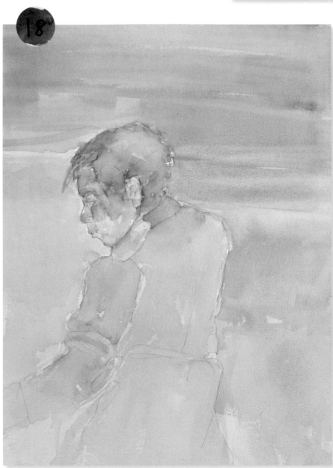

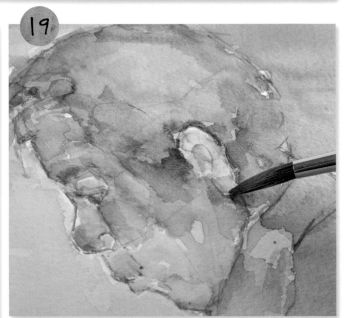

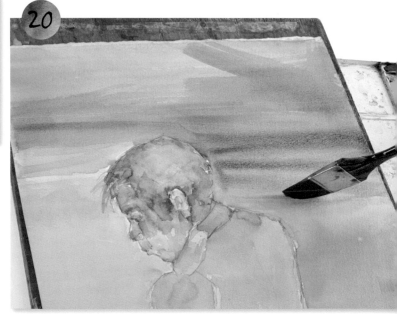

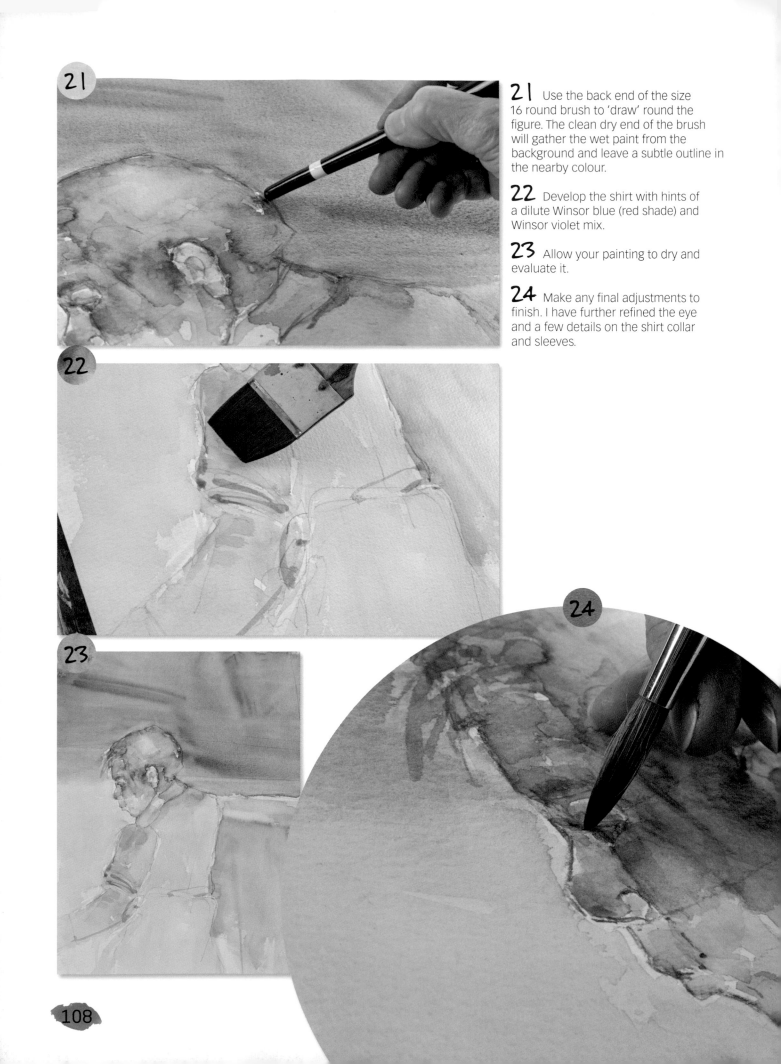

21 Use the back end of the size 16 round brush to 'draw' round the figure. The clean dry end of the brush will gather the wet paint from the background and leave a subtle outline in the nearby colour.

22 Develop the shirt with hints of a dilute Winsor blue (red shade) and Winsor violet mix.

23 Allow your painting to dry and evaluate it.

24 Make any final adjustments to finish. I have further refined the eye and a few details on the shirt collar and sleeves.

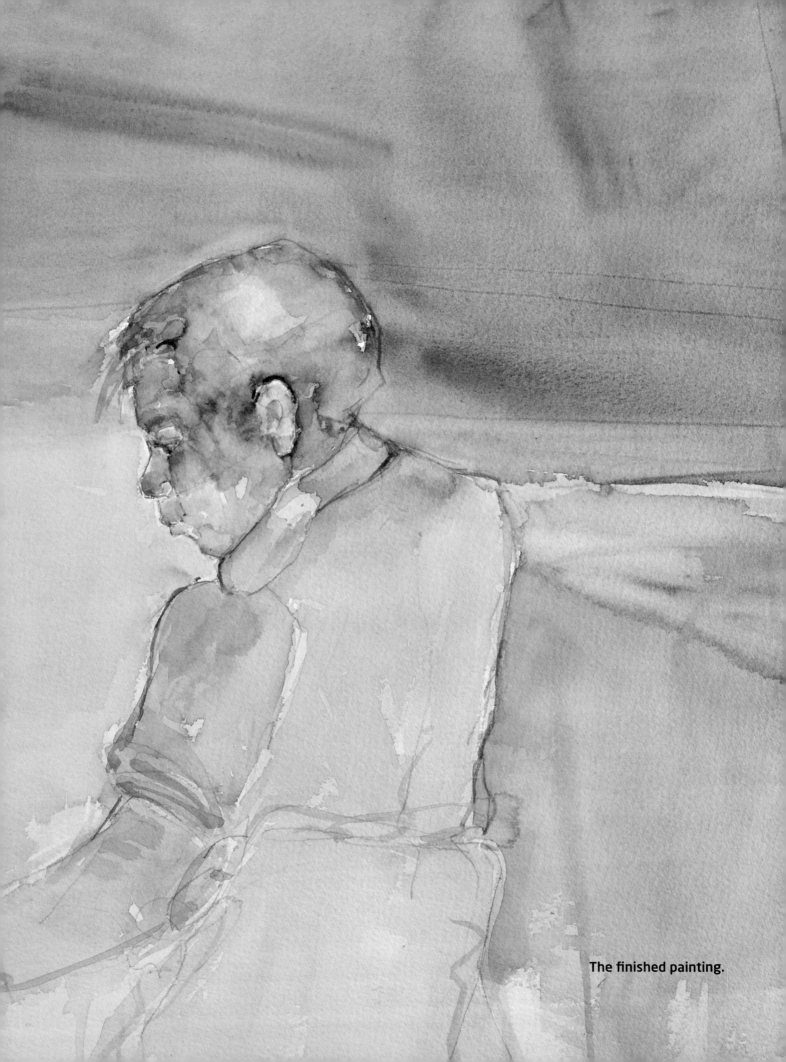

The finished painting.

INTO
ABSTR

JUST SEEMS TO GET BITTER AND

SUE. THE

W THE

SOU S I

I TURNED EACH

DESIGN TYPEPAD.COM

ACTION

WHY ABSTRACT?

I find enormous satisfaction in establishing the basic structural lines to build drawings, then resolving them into a finished painting. The next challenge is to take your work back to the barest minimum of parts that go towards picture making.

As we have seen up to this point in the book, the most fundamental components of picture making are shapes, and we have explored how to use shapes to create the illusion of a deeper space on the two-dimensional surface of the paper. In contrast, abstract art is concerned with creating two-dimensional images that have no particular reference to anything but themselves.

Modernism describes the artistic process of gradually taking away anything perceived to be superfluous. Using your watercolours for abstract art allows you more freedom in how you react to the world around you, and frees you to use pattern and vibrant colour with less concrete structure.

Pink Tulips
Tipping some shapes and extending others helps make a recognisable scene unfamiliar and diverting. There is still a suggestion of form created by the overlapping shapes, but they are rendered more eye-catching by their abstraction.

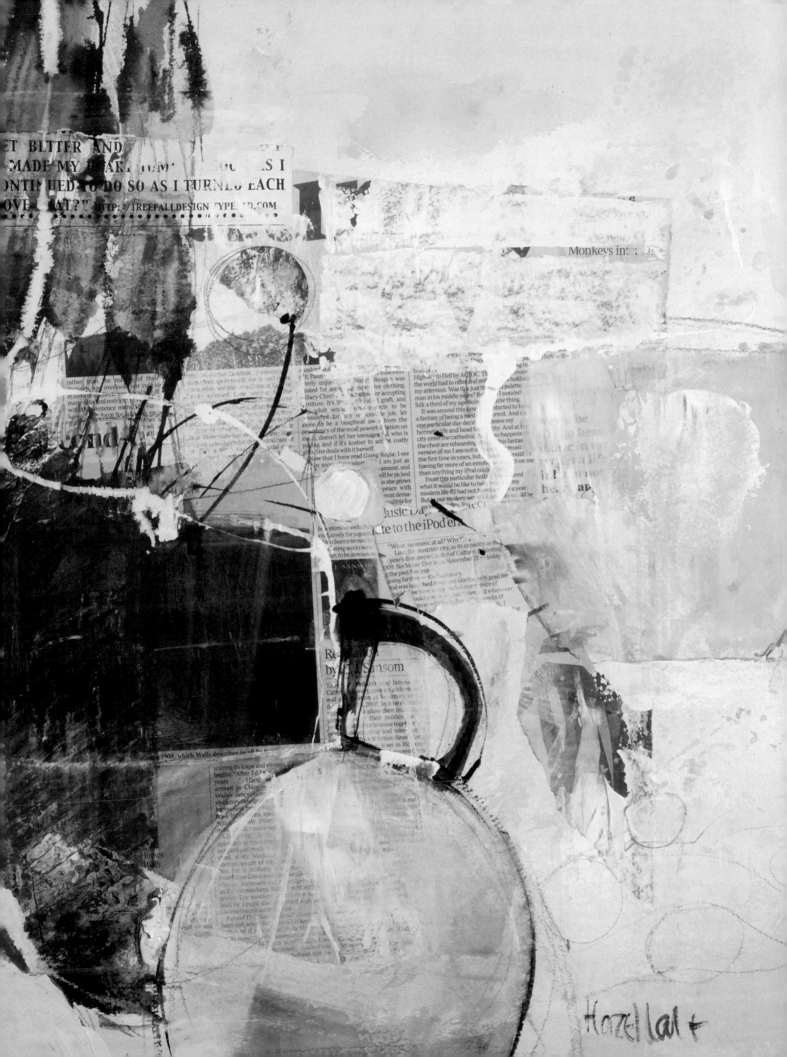

Your starting point

I have explored the subject of musicians in my artwork many times, and so feel comfortable with stopping on a busy street to do some quick sketches. The musician in this case was performing on a street corner, surrounded by people who had stopped to listen amidst the busy shoppers.

I wanted the finished painting to communicate the activity and noise that surrounded the musician as much as the figure himself, and so it was important to work out how I could communicate that visually.

I placed myself at a strategic distance with a good view to allow me to make quick drawings of the musician in action. I then turned my attention to the other instruments, boxes and musical stands around him. When you are presented with an overload of scenery and visual noise, it is always a good idea to look for shapes first and concentrate on keeping things simple.

Initial sketch
This sketch shows the beginning of exploring the subject. Built up from my thumbnail sketches made on site, I concentrated here on establishing the balance between the background and musician, treating them both simply as shapes of equal importance.

What to do

You can begin the process of abstracting the work by making a new sketch, using the lines from the original as a starting point but flattening and distorting them. Initially the shapes should remain somewhat recognisable but you are not necessarily aiming for the same illusion of depth and tone that you might find in a non-abstracted image.

Treat the background at this stage with the same importance as the figure: both should share positive and negative shapes. Look at the shapes you identified in the initial sketch (see opposite) and break the more complex curves and angles into fundamental shapes (see pages 54–55). For example, the head is broken into multiple simple shapes, such as a triangle for the nose and just four squares for the remainder.

Once this sketch is complete, repeat the process, making a third drawing based on the second. Try to ignore the original forms and concentrate on the patterns that the shapes form on the page.

Second sketch
Some of the original shapes remain 'piercing' the surface but most are abstracted into flat two-dimensional shapes. You might find it helpful to repeat this stage more than once, creating multiple different options.

Third sketch
Here, even more of the original shapes are abstracted into flat two-dimensional shapes. I have highlighted some of the patterns that occur with the addition of tonal hatching. This further distances the image from the original sketch.

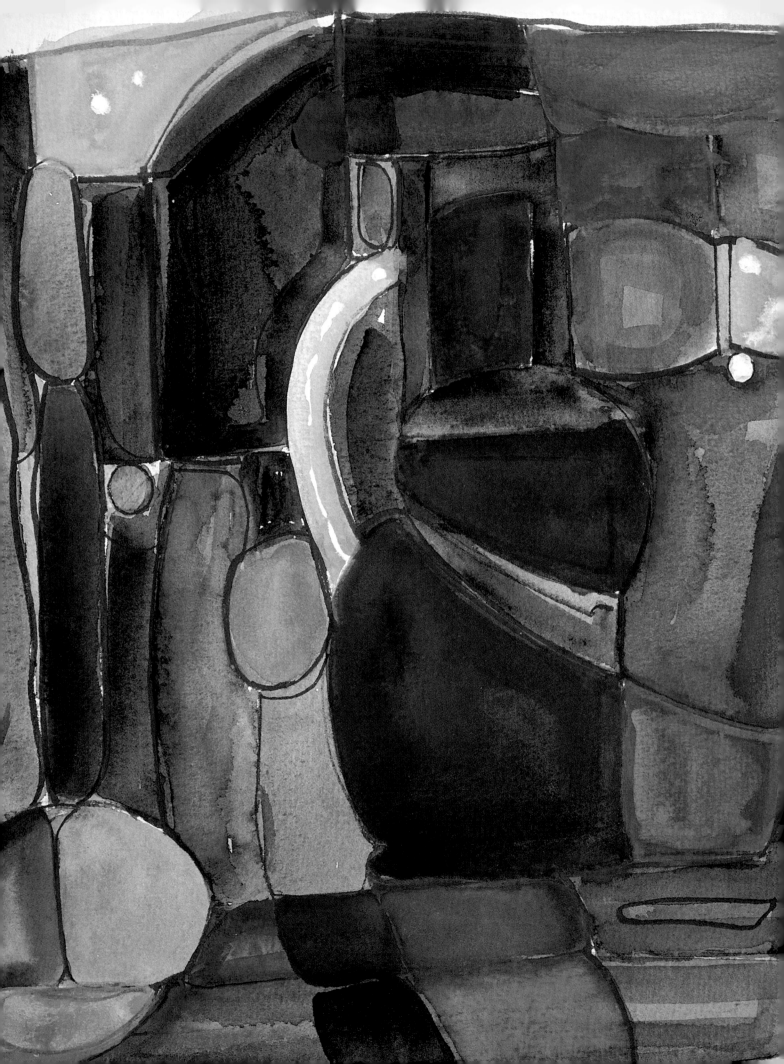

How far to take it

When it comes to painting, choices of colour are always optional, and this is particularly true for abstract or semi-abstract work. In the same way as you might render complex shapes into simple shapes then build them into a different pattern, you might choose to discard the original colours completely and choose a palette unrelated to the source material in order to further distance the image from the original.

Part of the beauty of abstraction is that you can take it as far as you like, staying close or moving further from realism as you wish. While the example below is still recognisable as a figure in the street, it is far more vibrant and striking than a photograph would have been, and the choices I made in terms of colour, line, shape, form, pattern – the elements of visual language – serve to communicate the noise and bustle of the moment. The more heavily abstracted version opposite communicates these in a different manner – perhaps more fluidly and directly.

Opposite:

Street Musician #1

Because my intention was to communicate vibrancy and noise, I wanted to break down the barriers between the musician and his surroundings and keep the balance between them equal. The forms of the musician and street are almost entirely lost, subsumed within pure, vibrant colour and abstract shapes. Compare and contrast the visual language used In this more abstract version with the lightly abstracted artwork below.

Street Musician #2

In this lightly abstracted version, I wanted the musician and surroundings to remain somewhat recognisable, so I decided to exaggerate the already striking colours that were already there. The dark grey shadows were replaced with Winsor blue (red shade), and the long luxurious camel-coloured coat was altered into a vibrant Winsor lemon. His bright red trousers seemed to connect with the bright colours of the surrounding shops, so I used the same hue in various places to create a sense of movement and rhythm. In much the same way, the bright Winsor lemon was echoed from the coat in some of the surrounding shapes, which gives a smooth visual transition from foreground to background. This draws the viewer's eye around the painting, preventing it from resting on the figure to the exclusion of the rest of the painting.

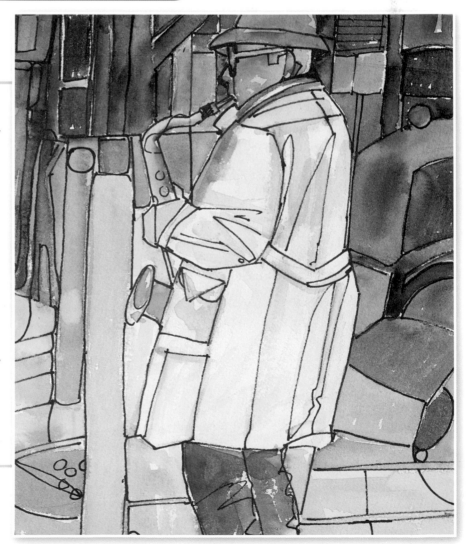

JOURNEY

For this abstract painting, I started with the concept of travel and connections and created a collage, incorporating an empty chair, an aeroplane and circular shapes to symbolise thoughts. Collage is useful to brainstorming and developing ideas as it involves selecting and rejecting shapes, patterns and colours as suitable – or not – for the piece.

You will need

- Watercolour paper, 640gsm (300lb) rough surface, 56 x 76cm (22 x 30in)
- Watercolour paints: Winsor violet, Winsor blue (red shade), scarlet lake, Bengal rose, cobalt turquoise light, Winsor red, brown madder
- Brushes: size 16 round
- 4B pencil and eraser
- Scissors
- White glue
- Collage materials
- Sketchbooks

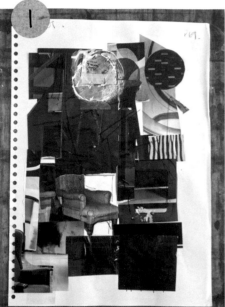

1 Use scissors and white glue to secure pieces cut from magazines and newspapers to a page in your sketchbook. Create a collage to help you decide on the composition and main shapes.

2 Use a 4B pencil to make increasingly abstract sketches of your collage composition following the processes explained on pages 114–115.

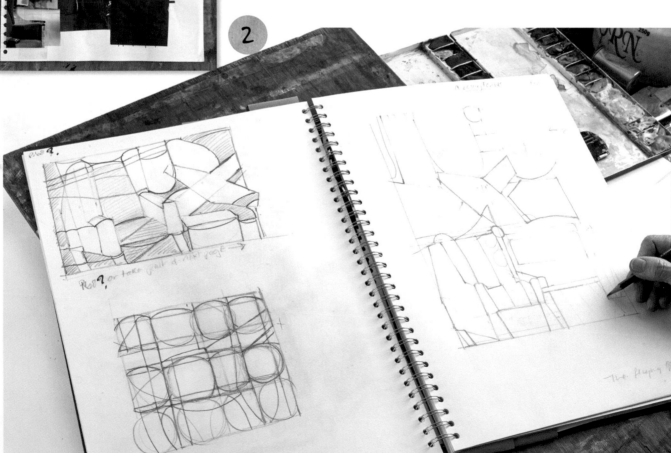

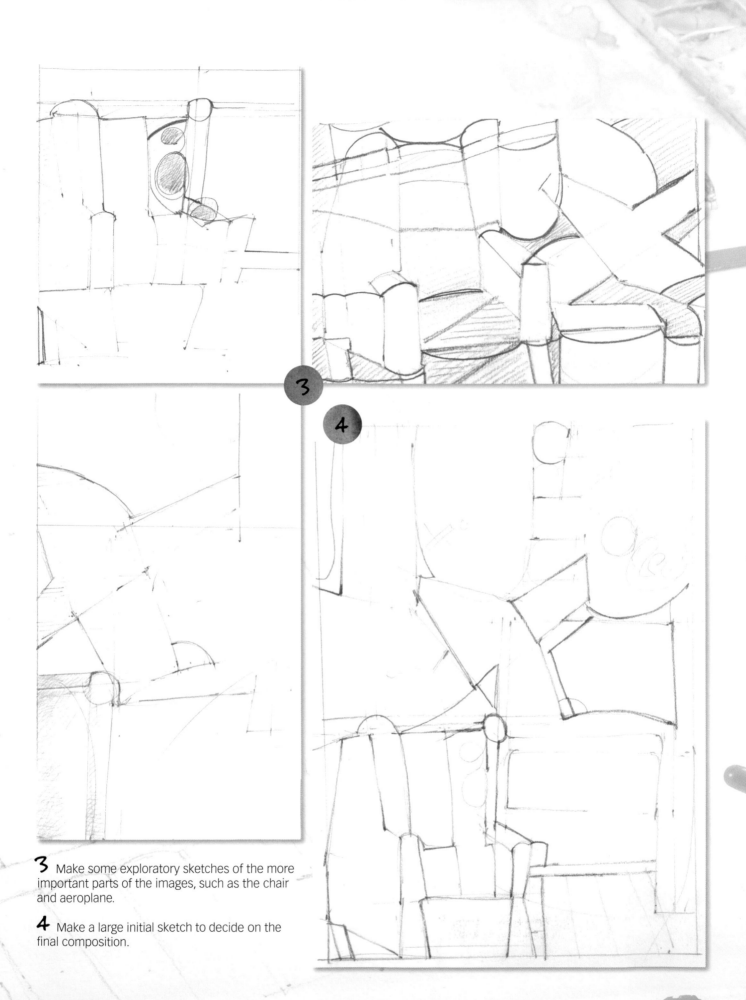

3 Make some exploratory sketches of the more important parts of the images, such as the chair and aeroplane.

4 Make a large initial sketch to decide on the final composition.

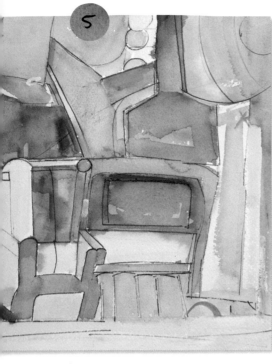

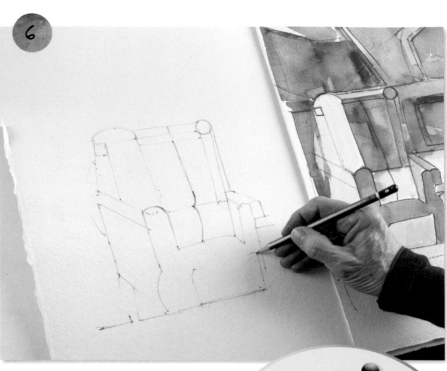

5 Use a copy of the initial sketch to work a colour run.

6 Draw out your final drawing using the colour run as a reference for the shapes. Start by drawing out the main elements to give you an anchor point for space when adding the less immediately identifiable areas.

7 Use the size 16 round brush to apply cobalt blue to the chair (which is the focal element) in sections. Drop in touches of Winsor violet and use pure Winsor violet to paint over one or two clean sections, too.

8 Paint some of the surrounding negative spaces with the same colours, and use Winsor blue (red shade) for more elements of the chair itself. Continue building up the chair.

TIP

The example colour run shown here (top left) shows an alternative palette of colours that I eventually rejected in favour of the scheme used for the demonstration. Abstraction allows you particularly great freedom in colour choice, so I suggest you make a number of very different colour runs before deciding on your final palette.

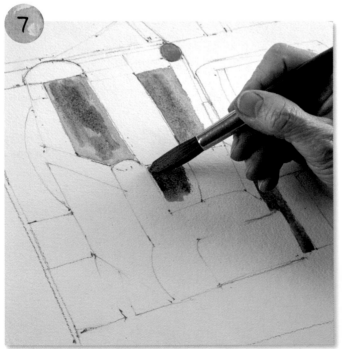

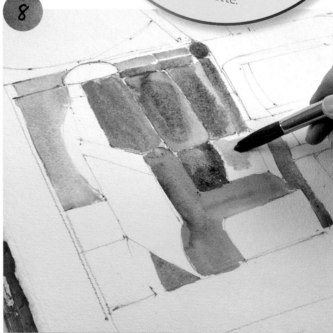

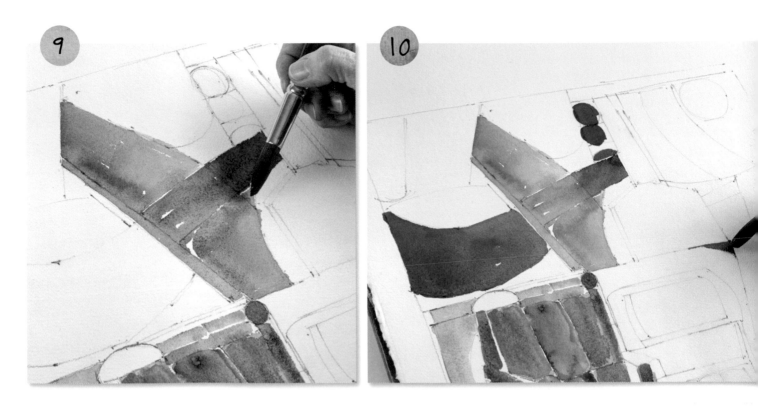

9 Still using the size 16 round brush, paint in the aeroplane using Winsor blue (red shade), varying the tone with differing amounts of water.

10 Use the size 16 round brush to paint areas that connect, lead through or point at the main elements with scarlet lake.

11 Add areas of diluted scarlet lake and strong Bengal rose near the bottom of the artwork

12 Continue building the painting by adding strong elements with pure cobalt turquoise light, Winsor red and Bengal rose.

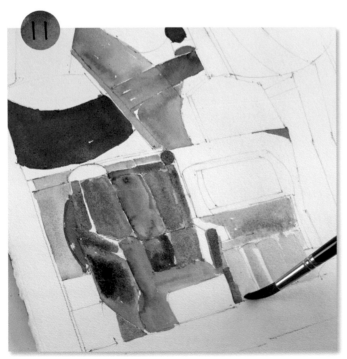

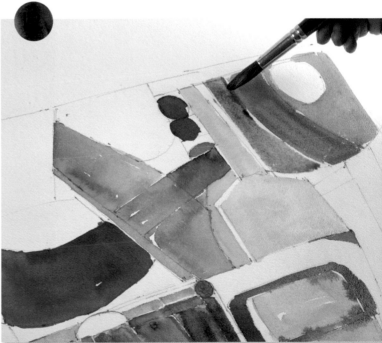

13 Add some deeper areas with pure Winsor violet and Winsor blue (red shade) mixed with a little Winsor violet, Winsor red and brown madder. Build up the areas gradually, avoiding working on areas next to wet areas (see inset).

14 Continue to build up elements including strong darks made up of Winsor blue (red shade) and brown madder. Place them between the brighter elements.

15 The strong darks help to separate areas, even when used very subtly. You can use the point of the size 16 round brush to work very fine lines that will work to push the other elements forward.

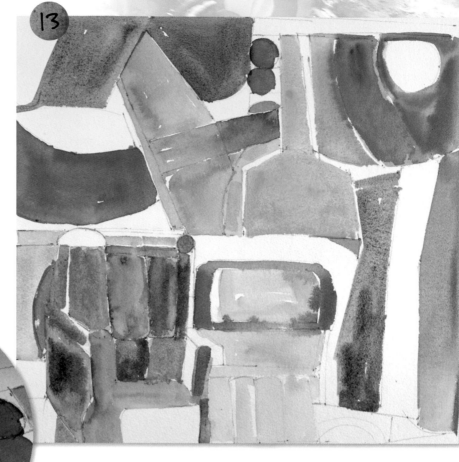

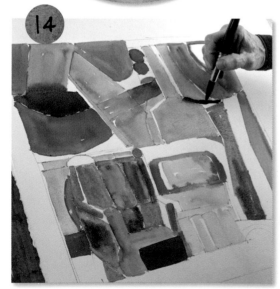

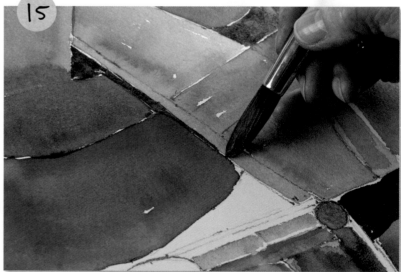

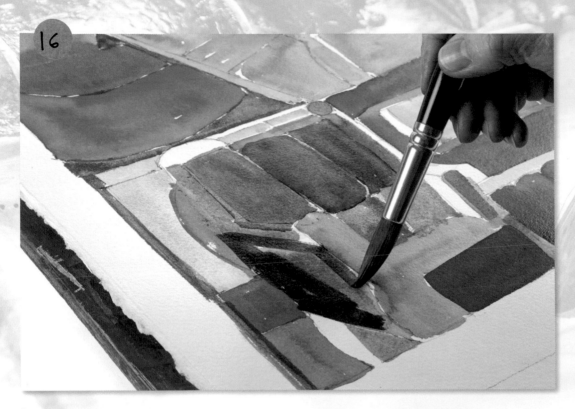

16 Continue filling the various areas, strengthening previous areas as necessary to bring them forward in balance with the newer ones.

17 As you continue to work, be careful not to make the areas of the painting too similar in tone – ensure you retain some light-toned areas.

18 Add a strong vibrant band at the base using Bengal rose and Winsor red to finish.

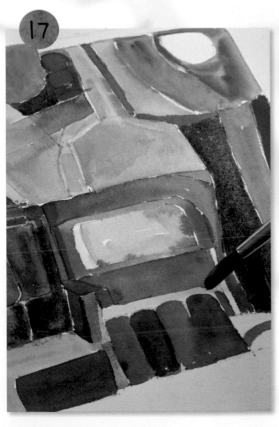

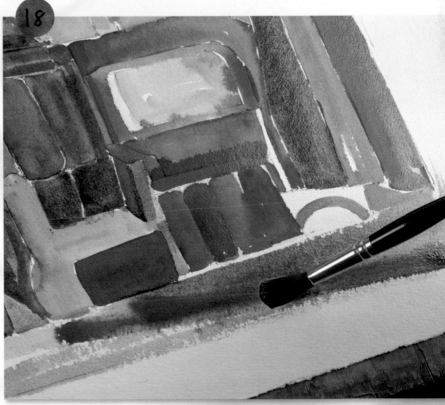

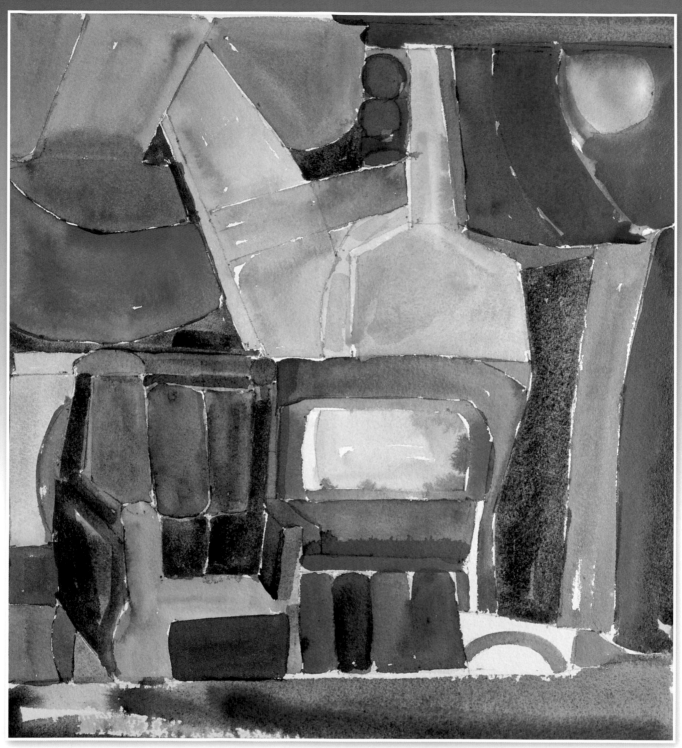

The finished painting

Opposite:
Armchair Dreaming

A more developed version of the demonstration painting, this is what I consider the final piece in a sequence that contains the sketches, colour runs and demonstration piece. Composed of watercolour paint and including paper collage, *Armchair Dreaming* is an example of how breaking down recognisable forms into a varied pattern allows you to use your capacity of imagination, without steering away too far from the fundamentals of creating a balanced rhythmic painting.